IMAGES
of America

MADISON

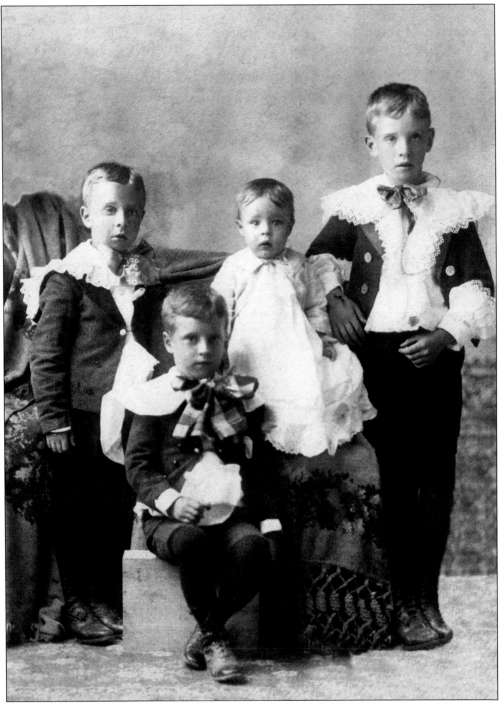

Four sons of Mr. and Mrs. Edward Behre posed in about 1905 for this family portrait. Their father by then was well established as one of the borough's premier producers of greenhouse roses for commercial markets. Son Charles is seated. Behind him are Edward, left; Henry, center; and David (the oldest), right. Sons were important to rose families: in time they could work in the labor-intensive greenhouses.

IMAGES
of America

MADISON

John T. Cunningham

ARCADIA
PUBLISHING

Published by Arcadia Publishing
Charleston, South Carolina

Printed in the United States of America

Library of Congress Catalog Card Number: 2004117136

For all general information contact Arcadia Publishing at:
Telephone 843-853-2070
Fax 843-853-0044
E-mail sales@arcadiapublishing.com
For customer service and orders:
Toll-Free 1-888-313-2665

Visit us on the Internet at www.arcadiapublishing.com

COVER: All activity stopped in Madison, NJ, early in August 1902, when a flash flood ripped through the Presbyterian cemetery, tossing caskets and bodies from about 50 graves (see p. 115).

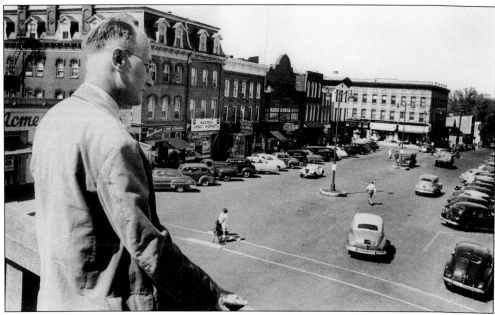

Looking down from the railroad overpass in about 1965, *Madison Eagle* publisher and editor John Ehrhardt could see all of one-block-long Waverly Place, Madison's impressive welcoming artery. The row of buildings on the left side of the street, minus the Victorian gingerbread, appears today much as it did in the 1880s and 1890s.

Contents

Acknowledgments 6

Introduction 7

1. On This Base 9

2. University in the Forest 29

3. The Subject Was Roses 37

4. A Legacy of Wealth 45

5. An Elevating Experience 67

6. Get a Horse! 77

7. The Heart and Pulse 87

8. Life Goes On 105

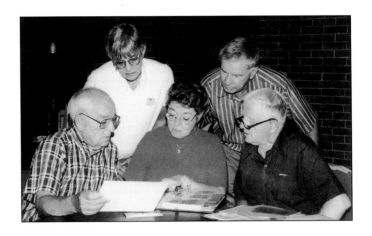

Acknowledgments

The committee that put together this volume (shown above) was comprised of the following, from left to right: (front row) John T. Cunningham, Helene C. Corlett, and Howard Wiseman; (standing) Maria W. Fenton and Andrew H. Bobeck. Mr. Cunningham directed the project, wrote the text, and made final decisions in the selection and placement of illustrations. Mrs. Corlett, representing Madison Public Library, and Mrs. Fenton, representing the Madison Historical Society, provided stores of information and made the initial choices of photographs and helped in selection and identification. They were aided in the latter by Mr. Wiseman, one of New Jersey's foremost picture experts. (A special commendation for Andy Bobeck appears below.)

The project began with endorsement from Nancy Singleton Vernon, director of Madison Public Library, and Barbara Benedict, a member of the boards of both the library and the historical society. We had full access to library and society picture collections. Other librarians and institutions that permitted use of photographs were as follows: Leslie Douthwaite, Joint Free Public Library of Morristown and Morris Township; Meg Struble, St. Hubert's Giralda Animal Welfare & Education Center; The Rockefeller Archives Center of North Tarrytown, New York; Janet Allocco, director, Madison Community House; Anthony Donato, downtown manager, Madison Borough; Jean Schoenthaler, head of special collections, Drew University Library; and Cathy Coultas, who loaned part of her collection of rose industry pictures. Especially helpful was the Thomas T. Taber Collection in the Madison Public Library.

Individuals who answered our plea for illustrations included Dr. Charles Robinson, Rob Ryan, the Cannon family, Mrs. George Burroughs, A.W. Beaman, Ann Marie Landishman, and Stephen Goumas.

—John T. Cunningham

We especially acknowledge the expertise and dedication of Andrew H. Bobeck, whose thoughtful and artistic computerized restoration and refinishing of about half the photographs in this book lent the artistry and clarity the illustrations now possess.

Introduction

Madison Borough transcends categorizing. Founded in about 1740 by rigid Presbyterians, the community has been for considerably more than a century a complicated blending of nationalities, ethnic groupings, religions, intellects, and economic levels. It has been home to millionaires, who first came as early as 1832; rose-growers, who began growing their delicate blooms at about the time of the Civil War; and Drew University, founded in 1866 by Methodists and underwritten initially by Daniel Drew, one of Wall Street's all-time scoundrels. Fairleigh Dickinson University has its front gate in Madison, although the campus proper is in Florham Park.

A history-changing railroad arrived in 1837. It created commuters, who began sprinting for trains to Newark and New York soon after the tracks were laid. Railroads also encouraged both immigrants and wealthy philanthropists to settle in the area and fostered a market for the town's unusual horticultural activities.

Madison is for me also a blend of warmly meshing emotions. Drew University is where I played baseball and earned a degree. It is the first town I "covered" as a beginning reporter for the *Morristown Record*, and is in essence where I began to learn how to write. Above all, it is where I met the young woman who would become my wife. Not incidentally, her ancestors included *both* town-founding Burnets (with one "t") and commercial rose-growing Behres.

Some of the Burnets, Carters, Bruens, Genungs, Millers, and other town founders have lain in the Presbyterian Hillside Cemetery between Kings Road and Main Street for more than 250 years. Their graves are on the top of the hill, where once the first church sat facing Kings Road, then the only thoroughfare through the infant settlement. Nearby are the large headstones of the Gibbons family that built the splendid mansion that became (and still is) Mead Hall, the heart of Drew University.

Beyond memories, few traces remain of the huge rose-growing industry, so vital and extensive that Madison once called itself "The Rose City." Welcome signs on several entering roads prominently displayed that nickname. Greenhouses began to disappear slowly in the 1950s. All of the growers—scores of them—were gone by the late 1970s, victims of high costs and outside competition.

Madison's nineteenth-century high point likely came on Christmas Eve 1889, when unincorporated villagers voted to withdraw from Chatham Township to incorporate Madison Borough as a separate municipality. Its twentieth-century turning point came just before

World War I, when the powerful Delaware, Lackawanna & Western Railroad elevated and straightened its tracks from Hoboken to Morristown, an incredible engineering feat in all towns along the line. Commuting increased for nearly half a century, and then began to decline after World War II. Commuters are still important, but the glory days when they dominated Madison's governmental, civic, educational, economic, and social trends are over, probably forever.

Waverly Place leads north from the tracks, as it has since horses and buggies met posh afternoon trains. Waverly is extra wide, the product of nineteenth-century Madison boosters who thought a grand street at the depot would impress visitors. That impressing had to be done in a limited area, for Waverly Place is only one block long. South of the railroad the street becomes Green Avenue; north of Main Street it is Central Avenue. Significantly, too, the west side of Waverly is much the same as it was a century ago, at least above the ground-level storefronts. The east side was decimated by nineteenth-century fires, changing its appearance markedly.

Drew University is the borough's major cultural and economic center. Its Methodist Theological School—the founding base—is recognized the world over, but Drew's Liberal Arts College—founded in 1928—currently enrolls about 1,400 young men and women and has the greatest impact on the modern town. The university's dozens of residential and academic buildings are set beneath huge oak trees, which give the institution its unofficial title, "University in the Forest." That designation was first used in the title of the school's official history: *Drew University: University in the Forest.*

Madison through the centuries has attracted many visitors, starting in 1825 when the Marquis de Lafayette included the village on his return visitation to the United States. It was not happenstance; a large contingent of French immigrants lived in or near the place. St. Vincent's Church, founded in 1839, owed its beginnings to this group. Soon after, a steady influx of Irish and Italians began. They came to work in the greenhouses, on the farms, in building trades, and as laborers and domestics. Black families were here long before the Civil War. It is likely that the first large group came to work on the estate of William Gibbons, who had large numbers of slaves on his Savannah plantation.

Philanthropists have contributed much to Madison—the first public library, the first YMCA, the first public park, the estate that became Drew University, Dodge Field, and, most impressively, the huge, multi-million-dollar municipal building donated to the town in 1935 by Marcellus and Geraldine Dodge as a memorial to their son who died in a European automobile accident.

Madison is about as complete as any small community can be as the twenty-first century bears down. It has enough ethnic and economic diversity to create self-examination, as well as enough vigor, prosperity, and intellect to strive for a better community. It has won wide attention for its thoughtful approaches to affordable housing, even as most of the erstwhile rose-growing properties have given way to construction of large houses. Madison remembers the past as it thinks of the future.

One

On This Base

The Samuel Tuttle Oak, longtime pride of Madison, stood for nearly three centuries on the Prospect Street hill that leads southward from town. Tradition says George Washington rested his horse under the spreading branches but nevertheless the tree eventually was named for Tuttle, the town's first historian. Wagon and buggy drivers, seldom in a hurry, enjoyed its shade. Late-sleeping twentieth-century commuters grumbled that the tree created traffic problems and should be cut down. Historians and environmentalists vowed to protect it. Fate decided the issue. The giant oak fell without fanfare on November 29, 1996, when struck by a passing truck.

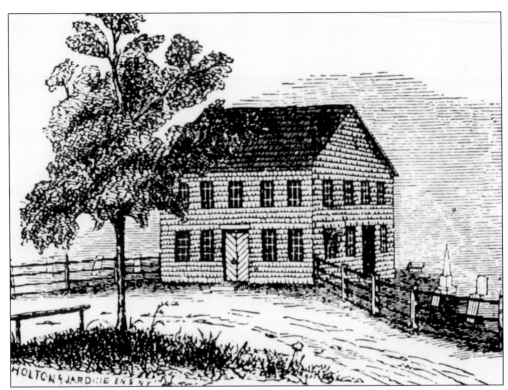

Madison began on the hilltop that parallels Kings Road. Early settlers built the rugged, two-story meeting house (above) in 1749 for worshippers who came from an area that included modern Chatham, Florham Park, Madison, and the rest of old Chatham Township. The burial ground (below) spread northward down the hill, continuing to expand even as the old church was replaced and torn down after 80 years of service.

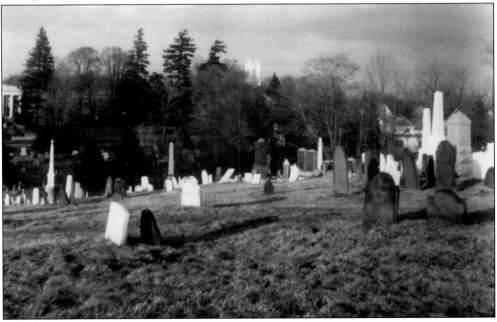

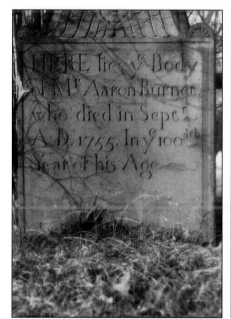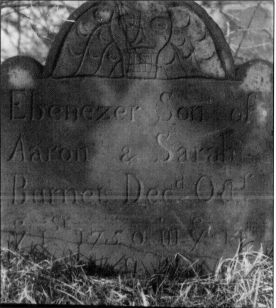

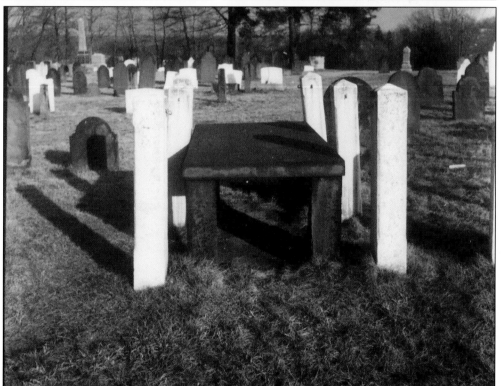

Major stones in the Presbyterian Hillside Cemetery mark the graves of Aaron Burnet and his son Ebenezer (top, left and right), who along with the Carters and others, arrived here in about 1745. Aaron died at age 100. The first settlers named the settlement Bottle Hill, allegedly after a local tavern. Even more prominent than the Burnet stones is the large, elevated table gravestone (bottom) of Rev. Azariah Horton, a highly respected pastor from 1751 to 1776.

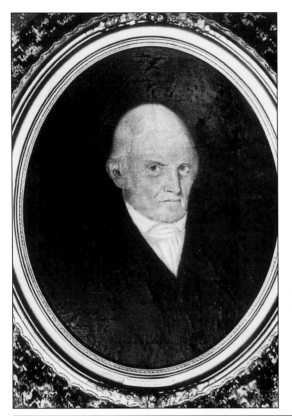

Probably the oldest dwelling in Madison is the Miller House on Ridgedale Avenue (below). Built *c.* 1730 by Andrew Miller on land purchased from David Burnet, the house is shown as it appeared about a century ago. It is now painted a pristine white. Here Luke Miller (left) was born in 1759. He enlisted in the Continental army at age 17. Miller returned to Madison and became a well-known blacksmith.

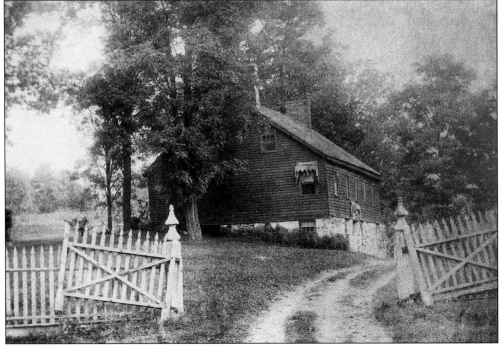

Tradition says that General Anthony ("Mad Anthony") Wayne stayed in the still-standing Sayre House on Ridgedale Avenue (above) for a brief period, possibly in 1777, when Colonial soldiers were at the nearby Loantaka encampment. South of the Sayre House on Ridgedale Avenue was (and is) one of the "bank houses" (below), so-called because the lower floor was built into the earth bank on the eastern slope of the hill.

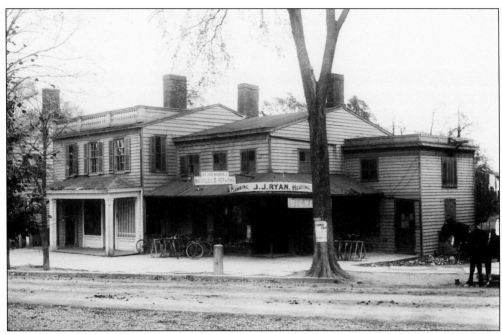

Two of Madison's oldest houses were the nineteenth-century George Sayre House that was once at 12 Main Street (above) and the older Joseph Winget House at 91 Woodland Avenue (below). The Sayre House and adjacent buildings were demolished to make way for the Main Street YMCA, opened in 1909. The privately owned Winget House, on the south side of town, dates to c. 1770.

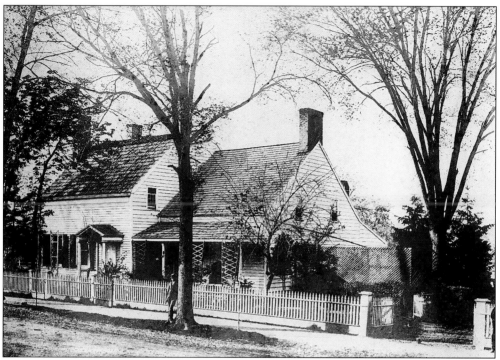

Madison has had several "Brittin houses" built by various members and at varying times by the Brittin family. Above is such a house, built by Col. William Brittin about 1804, one of the first structures to be erected along the newly finished Morris Turnpike (now Main Street). The house below was built at 83 Main Street by Colonel Brittin about 1830 for his widowed daughter, Anna Maria Baker. The house was demolished in 1936.

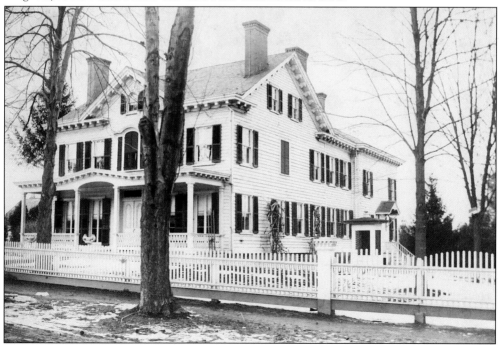

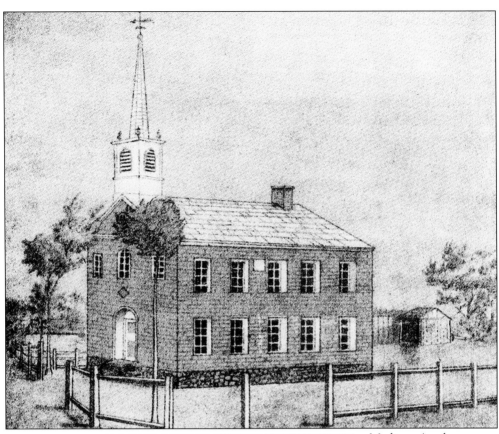

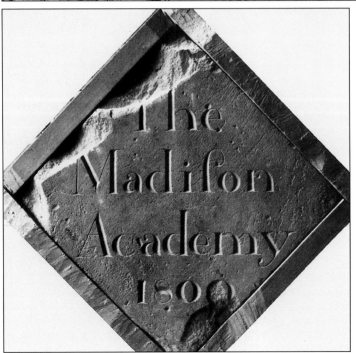

Madison Academy, opened in 1809 on Columbia (now Ridgedale) Avenue, was initially a Presbyterian-supported school but in time it became a highly respected independent institution. The original keystone (below) is owned by the Madison Historical Society. Constructed of brick, unusual for the time, the academy above was sketched in 1857 by historian Samuel Tuttle; the steeple was added in the same year. The structure was lost in an 1886 fire.

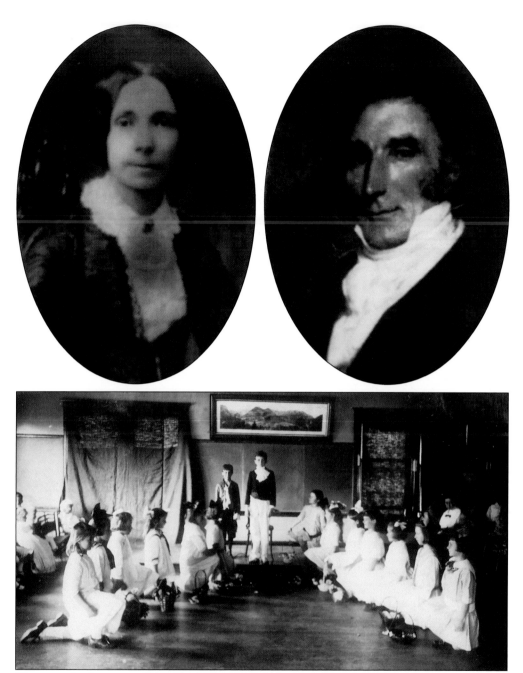

The town had a strong "French connection" for several decades after 1810, in the form of French refugees from the West Indies. Prominent among them was Hyacinthe Nicholas Blanchet (above, right), who bought the Howell House in 1812. His daughter Laura (above, left) was among 13 young women who greeted the Marquis de Lafayette when he visited the town in 1825. That meeting was reenacted at Madison Academy in 1914 (above).

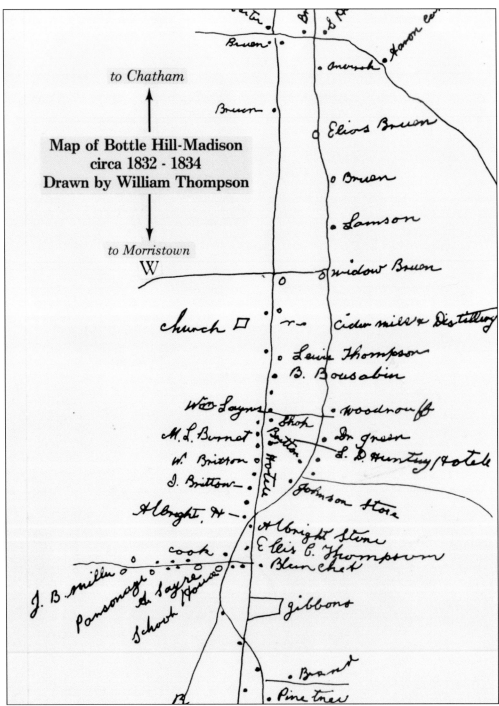

Map of Bottle Hill-Madison
circa 1832 - 1834
Drawn by William Thompson

to Chatham

to Morristown

W

Madison on the eve of growth was depicted in this map drawn about 1832-1834 by resident William Thompson. The long, straight street in the middle was Morris Turnpike, now Main Street. To the right was Kings Road, the original "Main Street." The roads met, as they do today (allowing for variances caused by time), at what much later became James Park. The names of Burnet, Brittin (or Britton), Sayre, Miller, and others are easily found here.

Two of Madison's most significant structures were the Madison House (above), opened in 1819 by Col. Stephen D. Hunting, and the Gibbons Mansion (below), built by William Gibbons in "The Forest," and first occupied in 1836. Now the historic heart of Drew University, the mansion was said to have cost about $100,000. Gibbons also paid about $35,000 for the 205 acres called "The Forest." The tavern (Madison House) was moved to a new location in 1923 and eventually destroyed.

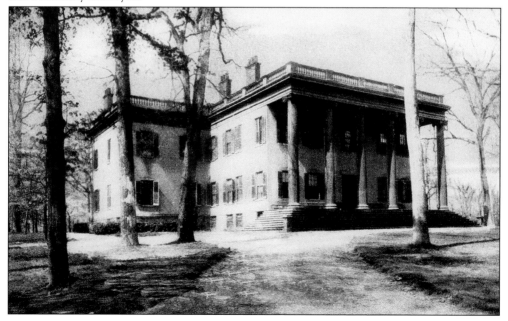

The village became Madison in 1834, to honor James Madison, fourth president of the United States (1809–1817). Temperance advocates supposedly were irked by the designation of "Bottle Hill," which supposedly was the name of a popular tavern. However, the name was used much earlier. The Madison Society, builder of Madison Academy, was formed in 1803 and the leading hotel was called Madison House in 1819. Major change centered on the arrival of the Morristown & Essex Railroad in 1837, pictured below as seen by historians Barber and Howe in about 1842. Main Street, dominated by a new Presbyterian church, can be seen to the rear.

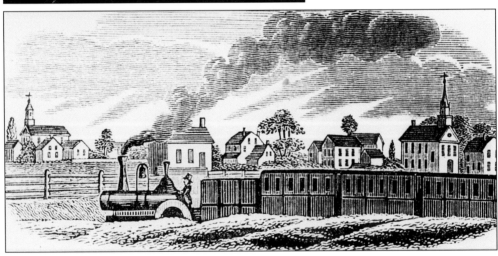

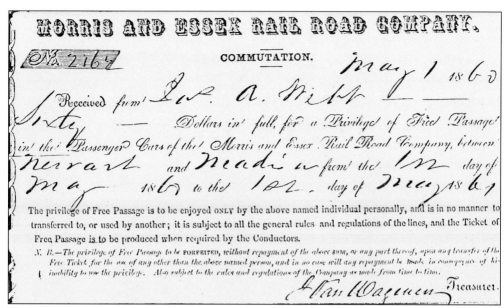

By 1860, when this Newark-Madison, year-around, commutation pass was issued to James A. Webb (a major town benefactor), Morris & Essex cars were filled with commuters going to and from New York or Newark. The so-called "free pass" cost $60 a year. The station (below) was still at ground level by 1900, served by horses and buggies. It was a proper and much valued subject for one of the postcards bought by visitors.

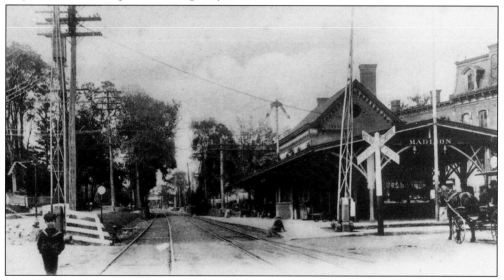

Madison's most familiar sight and sound for more than 100 years was a fast-moving, loud-chugging steam locomotive moving east out of town, headed for Hoboken. Each night, as their train slowed down, Madison commuters came close to their basic history—the old Presbyterian cemetery overlooking Kings Road (below). The roadway was still little more than a country lane by World War I, tucked between the railroad bed and the hill where the town began.

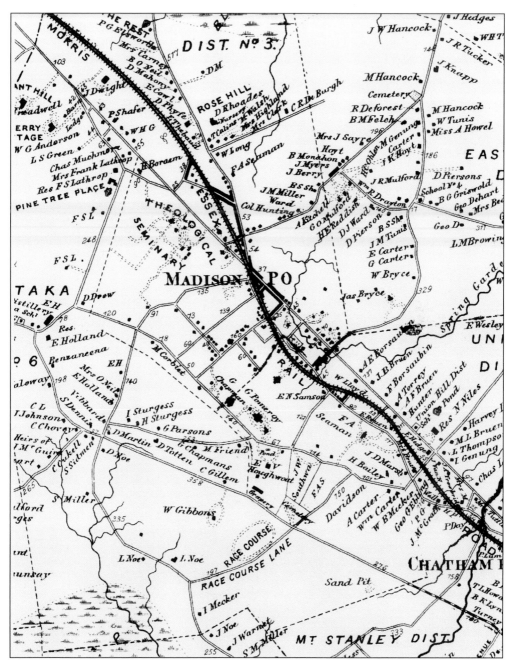

By 1868, when F.W. Beers included this map in his *Atlas of Morris County*, Kings Road and Main Street had not changed as far as their routes were concerned, although the number of Main Street buildings had increased markedly. Heavy railroad tracks dominated Beers' rendition of the growing town.

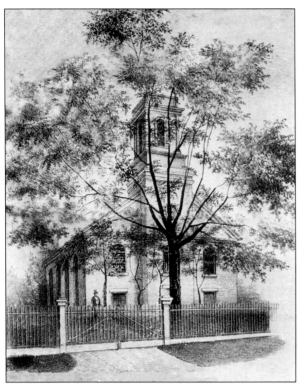

Madison's churches underscored the diversity of the town's population as the Civil War became reality. The Presbyterians built a new sanctuary (left) on Main Street in 1825. The influx of immigrants, mostly French, Italian, and Irish, required a new house of worship in 1839—St. Vincent's Roman Catholic Church at 61 Ridgedale Avenue (below). That building was remodeled into a private home when St. Vincent's erected a new church at its present location in 1912.

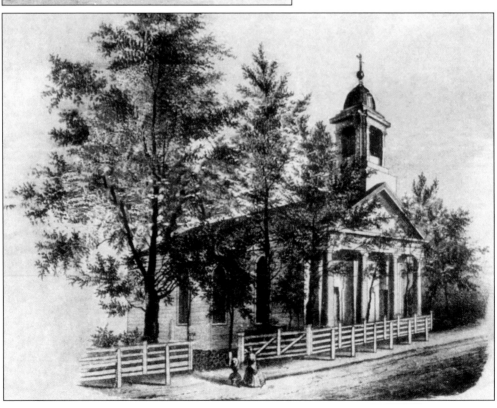

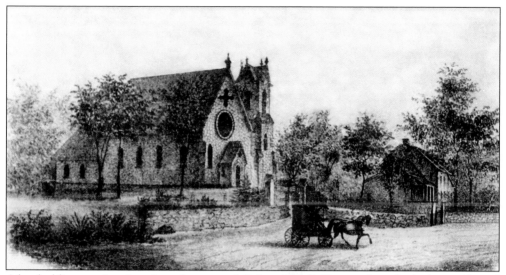

After holding services in private homes and Oriental Hall, Episcopalians built their still-used Grace Episcopal Church (above) on Madison Avenue. The first Methodist church, built in 1844 on Waverly Place, continues in partial disguise (below). When Methodists built a new church adjacent to Drew University, the old building's new owner jacked it up to put stores on the ground floor. The former round-topped church is easily recognized.

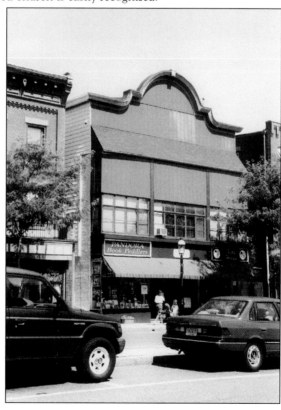

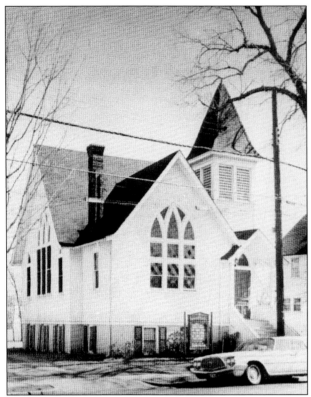

Madison's black residents had many places of worship before entering into permanent churches, Bethel A.M.E. Church on Central Avenue (left) and First Baptist Church on Cook Avenue (below). Bethel Church stems from the Union Church established at Cherry Hill (now Fairwoods). The present building was erected in 1885. First Baptist started in 1895 as a mission church on Central Avenue. The first service in the present church was held in 1902.

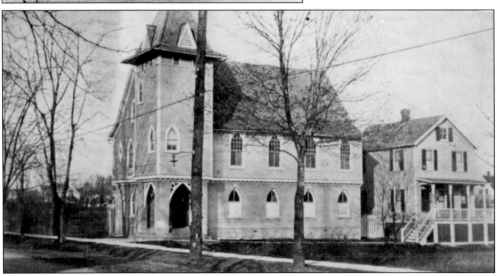

Madison enjoyed several turn-of-the-century years when vacationers arrived in carriages or train cars to savor "salubrious" air, "gorgeous" vistas, and country lanes. These could be savored at either the Ridgedale Inn (above), at the corner of Park and Ridgedale Avenues, or the American House (below) that faced Waverly Place near the depot. The Ridgedale Inn was razed; the American House, moved in about 1913, remains, much-changed, on Lincoln Place.

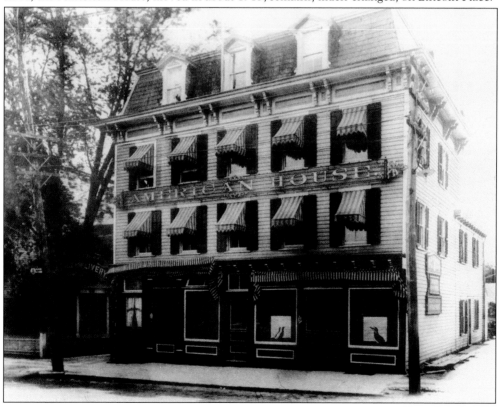

BUILDING LOTS AT AUCTION,
IN MADISON, N. J.

Will be Sold at Auction, on
WEDNESDAY, JUNE 10,
At 11 o'clock, A. M.,
On the Hill, South of the Village of Madison,
A LARGE NUMBER OF
VALUABLE BUILDING LOTS

Ranging from 50 to 100 feet in front, by from 200 to 325 in depth.

These Lots, which were formerly the property of Col. Wm. Brittin, but now the property of Samuel L. Tuttle, lie on the two new Avenues which have recently been opened on the Hill aforesaid, both of which are sixty feet in width, and lined on both sides with thrifty Maples; they command one of the most beautiful prospects in the State of New Jersey; are within sight of the Village and Railroad Depot; and are but five minutes walk from either.

Gentlemen doing business in the Cities of New York and Newark, and desiring a pleasant Residence in the Country, within one and a quarter hours' ride of the former, on one of the most pleasant Railroads, and in the midst of some of the very finest scenery in Auction, would do well to view this property.

The Sale will take place on Wednesday, the 10th day of June next, at 11 o'clock, A. M., or on the next fair day at the same hour, if that day should prove stormy.

Persons from New York and Newark can come up in the morning train, which leaves Madison at 10 o'clock, and return by the train which leaves here at 5 o'clock, P. M.

TERMS:—One-Third Cash on the delivery of the Deed; One-Third in One Year; and the remaining Third in Two Years.

TITLE PERFECT.
STEPHEN D. HUNTTING, Auc'r.

Madison, N. J., May 5, 1857.

Douglass & Starbuck, Printers, 143 Market Street, Newark, N. J.

Inevitably, real estate developers began cutting up the town. On June 10, 1857, building lots "on the hill, South of the village" were auctioned, opening the way for modern tree-shaded Maple Avenue, said by the builders to be 60 feet wide. A half-century later, the result of that 1857 auction was easily visible in the row of substantial homes seen on the street beyond the new Presbyterian Webb Chapel, in the near foreground (below).

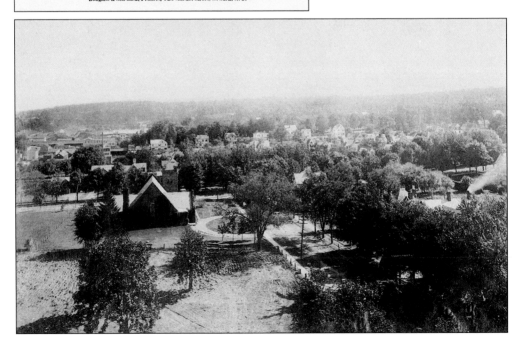

Two

University in the Forest

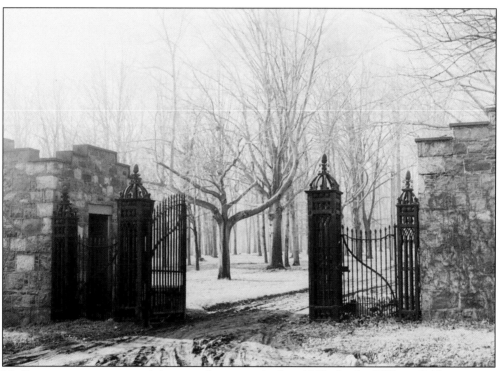

Madison masons constructed these gatehouses in the late 1830s for the William Gibbons estate in "The Forest." After the estate became Drew Theological Seminary in 1866, students, faculty members, and visitors entered here. The old entrance, too small for automobiles, was replaced in 1921 by the slightly wider Bowne Gateway. Drew opened its doors to liberal arts students in September 1928, after brothers Leonard and Arthur Baldwin of East Orange donated $1.5 million to build and endow an institution named "Brothers College" to honor the donors. Today the college, renamed prosaically The College of Liberal Arts, is dominant on campus. The seminary continues as a world-famed center of religious excellence.

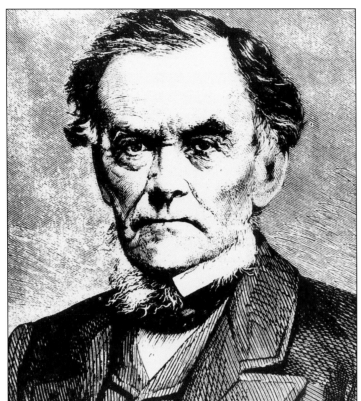

Always as benign as a lamb when he attended meetings in Madison, Daniel Drew, chief (and only) benefactor of Drew University at its founding in 1866, posed for this magazine etching at a time when he was known in New York City as "The Jackal of Wall Street."

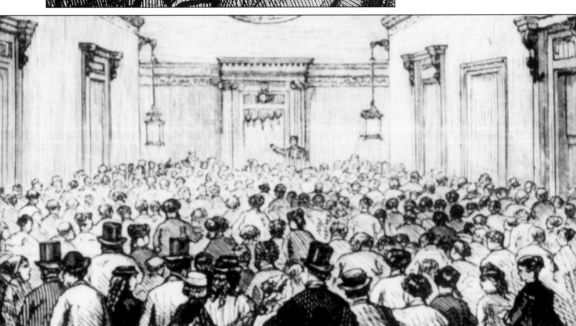

An artist for *Frank Leslie's Popular Monthly* magazine sketched this scene when Drew University was formally opened on November 6, 1867, at a gala affair in the former Williams Gibbons mansion, the center of training for Methodist ministers.

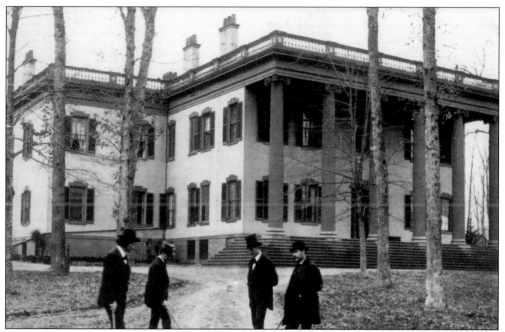

Drew students, c. 1880s, struck a relaxed pose when photographed near Mead Hall (named for Daniel Drew's wife, Roxanna Mead Drew). The game of the period was croquet, played here on the rutted driveway in front of the mansion.

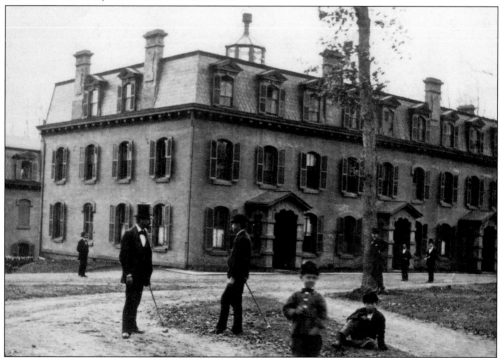

Carefully placed Drew theologians posed in the 1880s for a publicity shot. The building in the rear is Asbury Hall, the former Gibbons stable that was cleaned and converted into a still-existent campus dormitory.

31

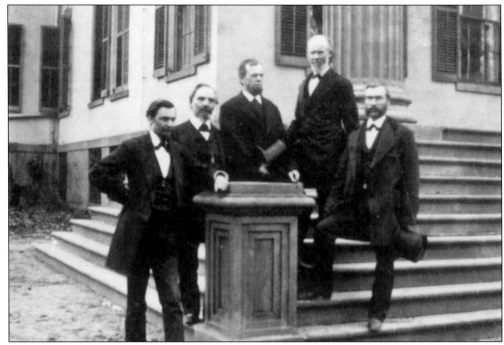

This is the entire Drew administration and faculty in the 1880s. The quintet included Dr. Henry Anson Buttz, fourth university president (left), and Dr. John Fletcher Hurst, third president (center), recognized as the university's savior when Daniel Drew became bankrupt in 1873.

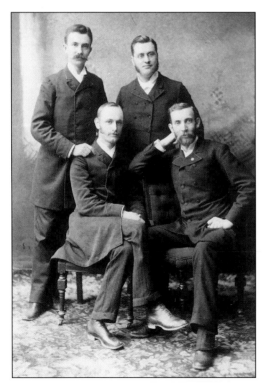

"The Forest Quartet," whose identities unfortunately have been lost in time, was a popular feature at every campus social and religious gathering. The group's programs included both hymns and popular harmonies of the day.

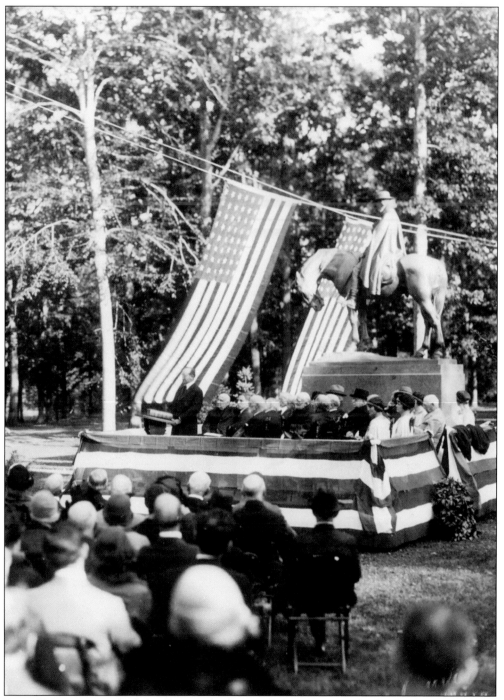

Drew University reached deeply into fundamental American Methodist history on October 14, 1926, when it dedicated the notable statue of Bishop Francis Asbury, famed "circuit riding" preacher of the Methodist church. His peripatetic horseback ministry extended from 1771 to 1817 and spread Methodism through nearly all states east of the Mississippi River.

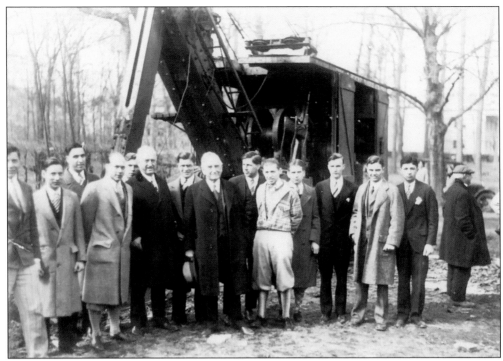

Leonard and Arthur Baldwin and the first freshman class at Drew's new College of Liberal Arts attended groundbreaking ceremonies in 1928 (above) for the college the brothers had endowed. This ceremony was followed about a year later by dedication of the acclaimed "Brothers College," the $500,000 structure (below) that offered "an adventure in excellence." The Baldwins also gave an endowment of $1 million for the college.

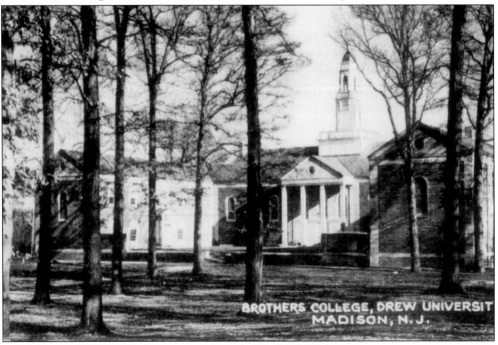

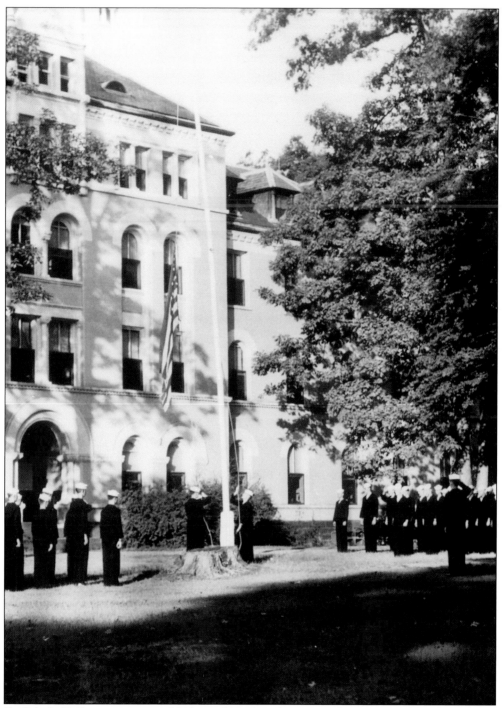

On July 1, 1943, a contingent of 200 naval V-12 students arrived on campus. The V-12 (called "the whites" for their uniforms) became Drew's most unusual student group, pursuing the same courses as other undergraduates, including women ("skirts" to the navy) and a small number of deferred males ("civvies"). In early morning ceremonies each day, the sailors raised the American flag in front of their dormitory, nicknamed "U.S.S. Hoyt Bowne."

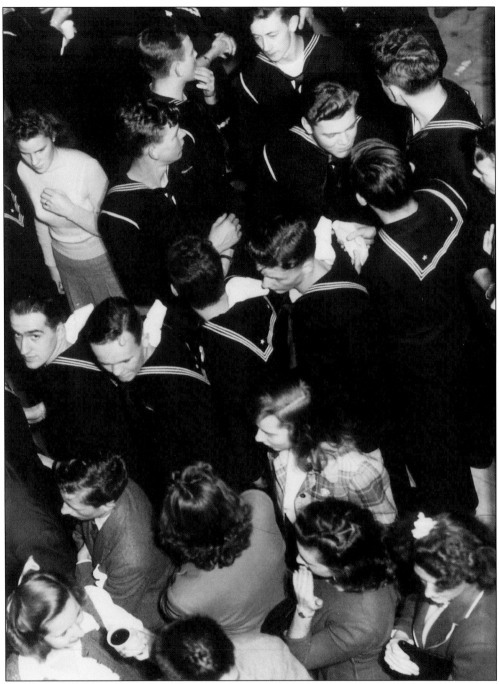

From the standpoint of the 100 or so women students, the presence of 200 sailors created a social dividend. Young women from the town also attended dances and other affairs on the Drew campus. The sailors left before peace arrived but many of them returned later to earn Drew degrees, and, in some cases, to marry girls they had left behind when they left for war.

Three

The Subject Was Roses

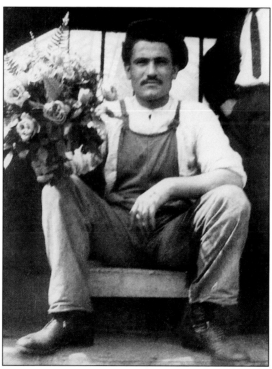

In about 1900, Amadeo Micone, member of a well-known Madison family, sat on the steps of one of Edward Behre's greenhouses on Garfield Avenue, holding a few of the famous blooms that earned Madison its once-revered nickname, "The Rose City." The town enjoyed more than a century of prominence as one of the nation's prime producers of roses grown under glass for commercial sale. More than 45 rose growers thrived in Madison in 1896, when a survey showed the growers had an astonishing half-million square feet of glass in their greenhouses. Hundreds of men worked in this major industry that reached its peak in 1950, then gradually faded and was completely gone by 1980.

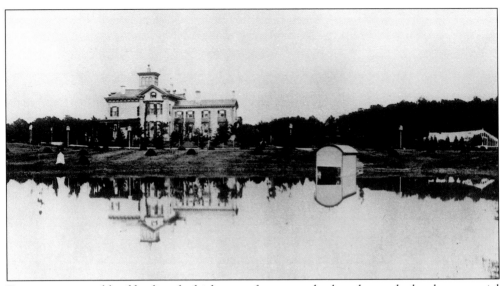

Estate owners capable of funding the high costs of year-round culture began the local commercial rose industry in about 1856. The first major producer was T.J. Slaughter, whose estate (above, as it appeared in 1877) featured five greenhouses, one of which can be seen to the right. The greenhouse on the Seaman estate (below) typified nineteenth-century construction. By 1889, Madison's 35 growers shipped roses to New York City markets by train.

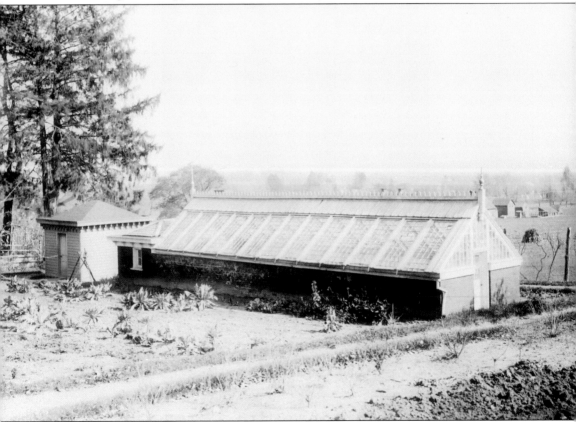

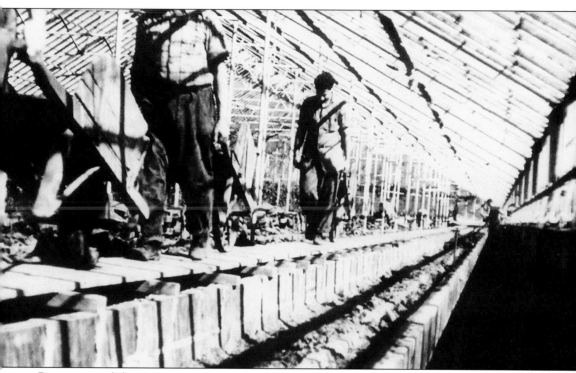

Roses required the constant attention of workers who toiled year-round under vast expanses of glass, wheeling clean soil to depleted rose beds, applying fertilizer when needed, and constantly fighting plant diseases and insects.

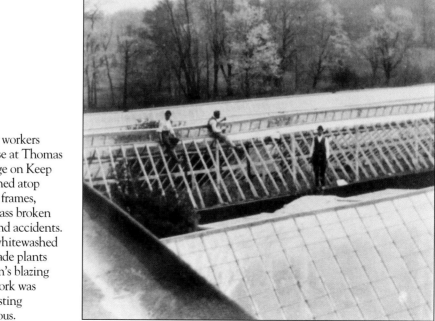

In summer, workers such as these at Thomas Keefe's range on Keep Street perched atop greenhouse frames, replacing glass broken by storms and accidents. They also whitewashed panes to shade plants from the sun's blazing rays. The work was both exhausting and dangerous.

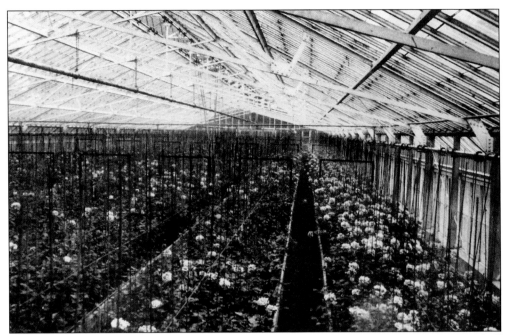

Alphonse Troianello's establishment on Burnet Road (near the present high school football field) became a housing development in 1950. He sold his two greenhouses to a florist, who re-erected the glass structures in Freehold.

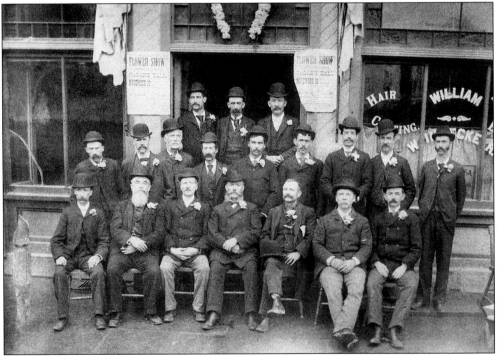

The Madison Rosegrowers Club posed in front of Fagan's Hall (Waverly Place) in 1895, a year after organizing to promote their joint commercial interests. Most of the club originators were from recent Irish immigrant families.

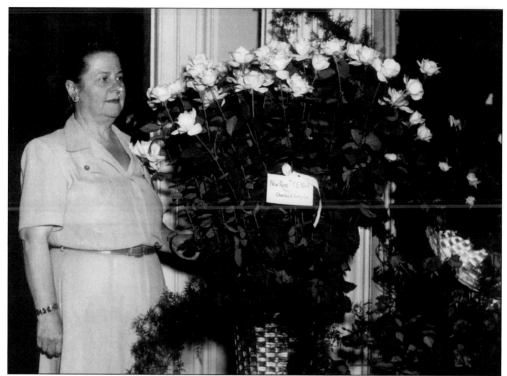

Helen Totty (above), daughter of noted English horticulturist Charles Totty, was until her retirement in 1962 the only major woman commercial rose grower in the nation. Robert Nichols (right) became part of the industry by his marriage to Wilma Ruzicka of the rose-growing Ruzicka family. He brought engineering and scientific skills to the huge Watchung Rose Corporation that annually produced three million roses.

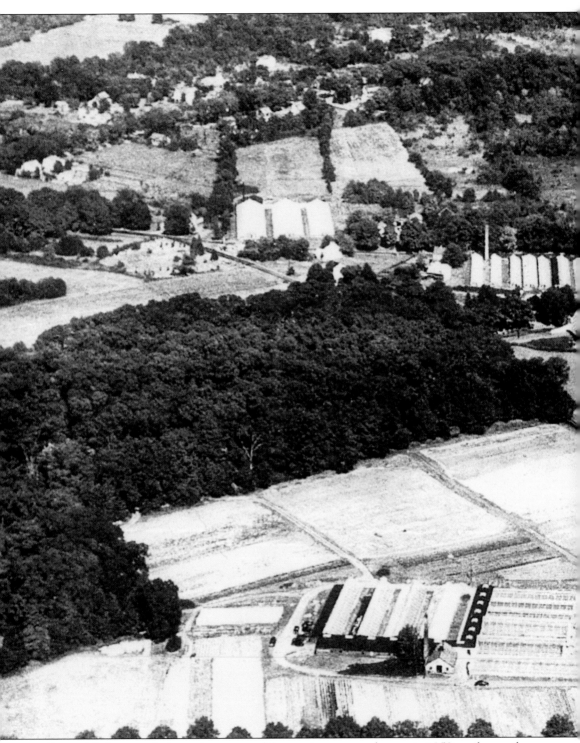

An aerial photograph shows the extent of the area's rose greenhouses in 1950 on the northern edge of town where Florham Park abuts Madison at Ridgedale and Greenwood Avenues. Soon all of this would vanish. Several greenhouses were razed to make way for State Highway 24.

42

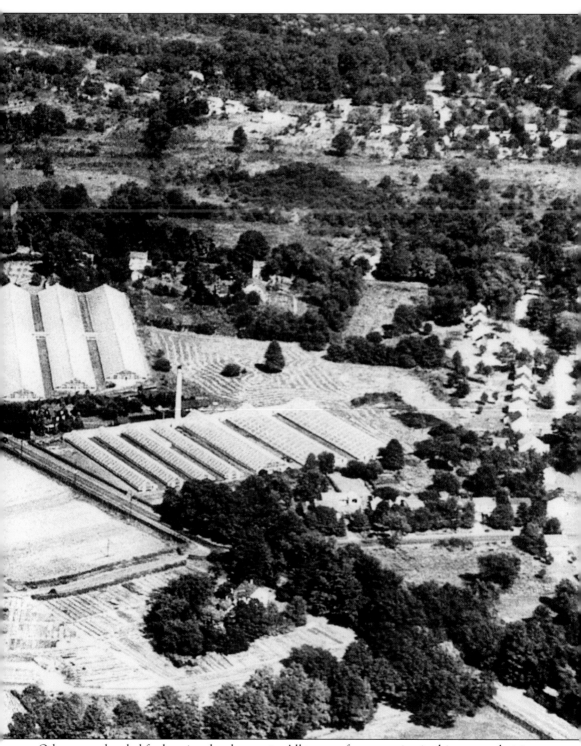

Others were leveled for housing developments. All traces of rose growing in this area are lost in the mists of time.

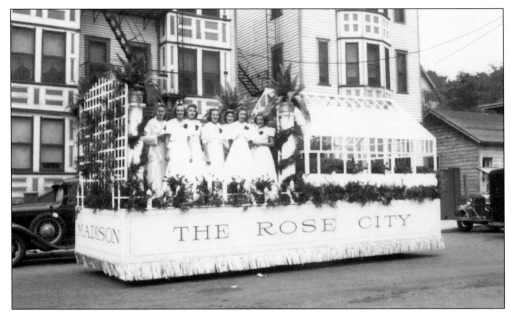

Madison never missed a chance to spread word of its unique rose prominence. Several of the town's most beautiful young women (above) adorned a float for a parade in Morristown to celebrate Morris County's 250th anniversary in 1939. Madison Chamber of Commerce representatives (below) put the final touches on a rose-covered float that appears ready to participate in a local parade.

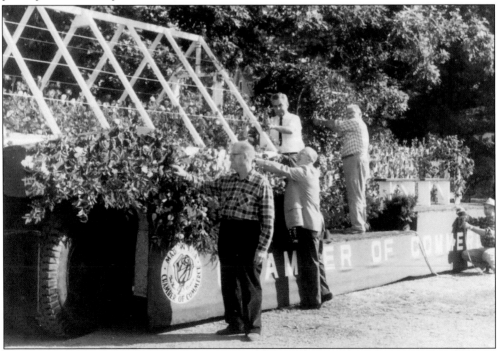

Four

A Legacy of Wealth

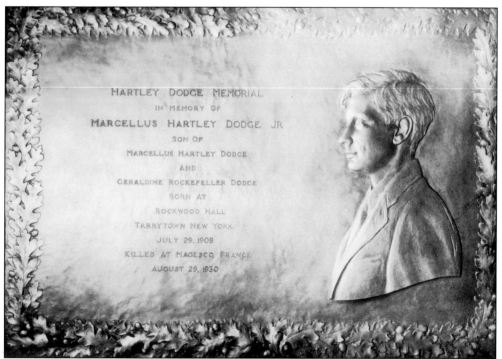

HARTLEY DODGE MEMORIAL
IN MEMORY OF
MARCELLUS HARTLEY DODGE JR.
SON OF
MARCELLUS HARTLEY DODGE
AND
GERALDINE ROCKEFELLER DODGE
BORN AT
ROCKWOOD HALL
TARRYTOWN NEW YORK
JULY 29, 1908
KILLED AT MAGESCQ FRANCE
AUGUST 29, 1930

The town's most dramatic symbol of fabled fortune and gracious generosity is the imposing borough hall. As the dedicatory plaque shows, the Hartley Dodge Memorial honors the only child of Marcellus Hartley Dodge Sr. and Geraldine Rockefeller Dodge, Madison's all-time wealthiest family. A century ago, many other well-to-do people lived in the borough. Hamilton McKay Twombly and his wife, Florence Vanderbilt Twombly, two of the nation's richest people, lived nearby in Florham Park. Few of the wealthy people were Madison benefactors; most lived here and had major philanthropic interests elsewhere.

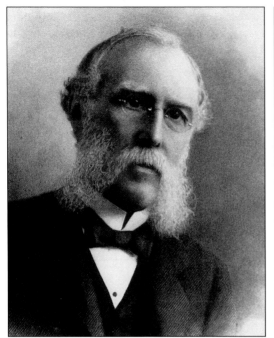
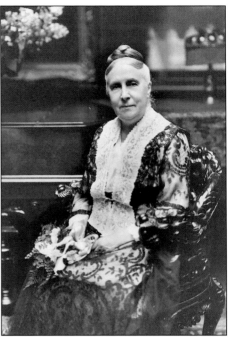

James Augustus Webb, New York manufacturer of industrial alcohol, and his wife, Margaretta Baker Webb (both above), were among Madison's earliest philanthropists. Margaretta Webb was a member of the distinguished Brittin-Baker family before her marriage to Webb. The couple lived in several Madison mansions, including "Wyndehurst" (below) at 253 Woodland Road.

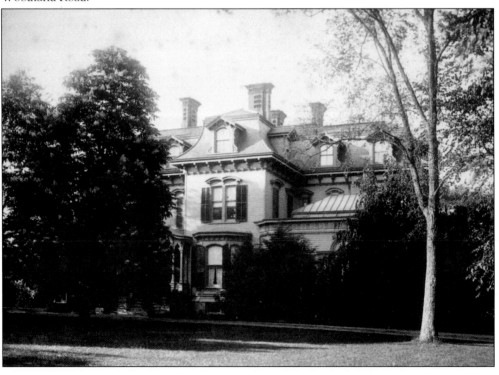

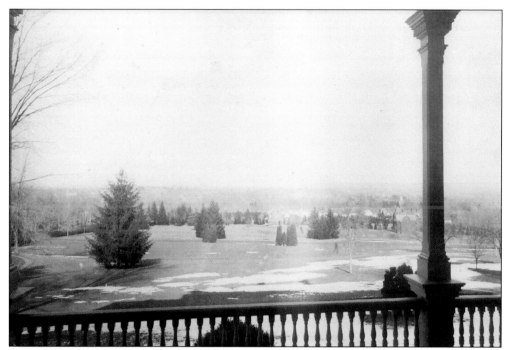

The view from the Webb porch at 253 Woodland Road was magnificent. Looking northward in 1890, the family could see the steeple of Webb Memorial Chapel. Beyond the Wilmer Street trees, they also could see Ridgedale Avenue.

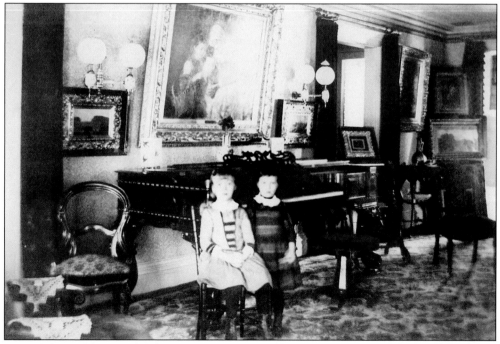

Two of the Webb's grandchildren, Margaretta and Eleanor Holden, sat for this formal picture (*c*. 1890 or slightly earlier) in the living room of another house where the Webbs lived at the corner of Green Village and Kings Roads.

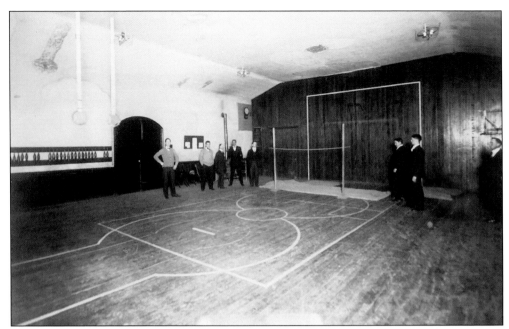

Webb's first important interest in Madison was the YMCA, which he helped found in 1873. He served as second president when the early "Y" existed on the second floor of the Brittin Building on Main Street. It boasted a small gymnasium (above). The YMCA pool hall (below) featured a decorated tin ceiling and a pot-bellied coal stove. At the rear of the hall, the YMCA's small library can be seen.

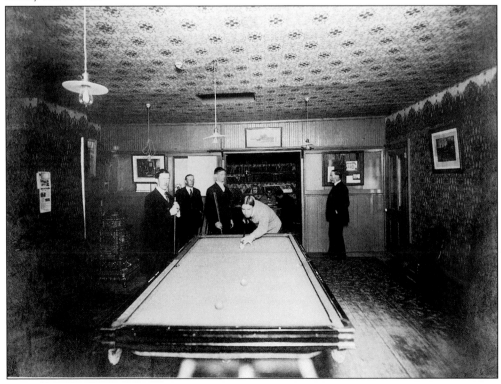

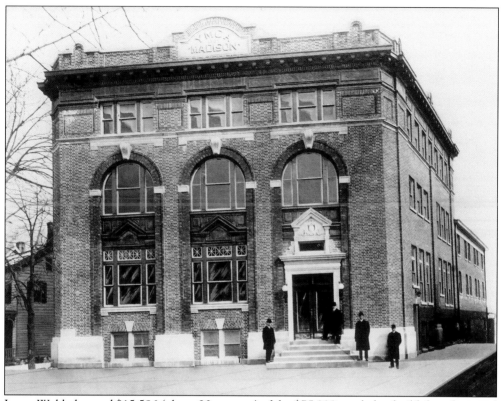

James Webb donated $15,586 (about 20 percent) of the $75,228 needed to build the substantial new YMCA (above) dedicated in 1908 on Main Street, across from the James Library. The facility had bowling alleys, a good gym, a swimming pool, and the inevitable pool room (below). Webb's interest in the YMCA continued until his death in 1910.

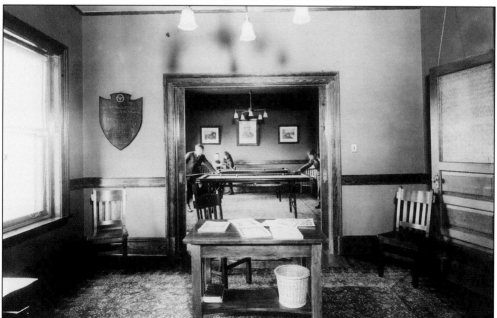

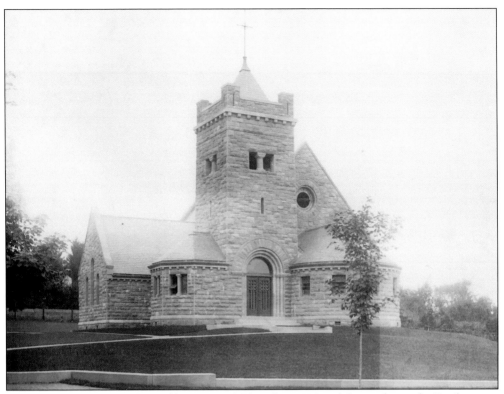

Webb and his wife built the Webb Memorial Chapel in 1888 and donated it to the Presbyterian church as a memorial to their son, James A. Webb Jr., who died on April 6, 1887. The Gothic structure now stands beside the new church erected in 1954.

Expanding his interests, Webb provided land and donated a clubhouse to the Madison Golf Club in 1903. He also worked to bring Madison its electric plant and waterworks and helped insure telephone service by guaranteeing 20 customers.

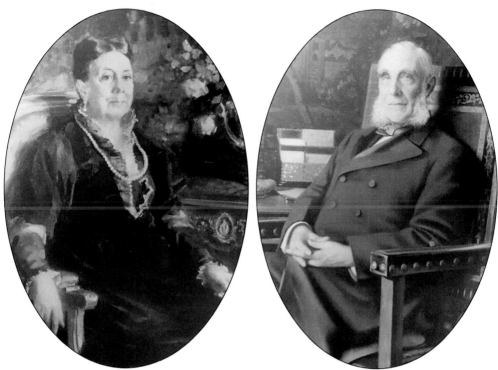

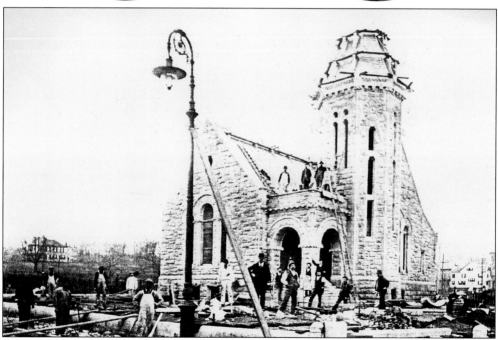

Ellen Stebbins James and her husband D. Willis James (both top) were among Madison's all-time leading benefactors. In 1898, Willis James turned swampland along the western end of Main Street into James Park. In 1899, he built and donated the James Public Library (bottom) to Madison. The Romanesque-Gothic structure served until 1969, when a new public library was erected on Keep Street.

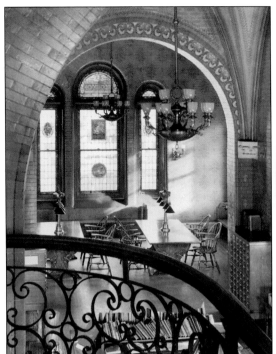

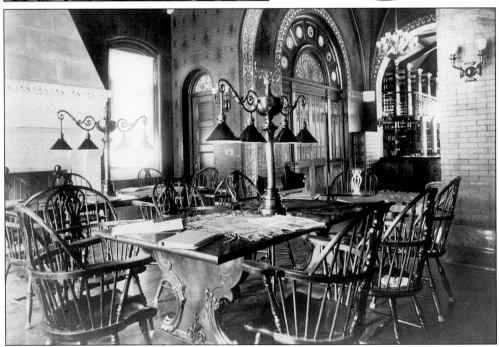

Bertha Wildman (top right), Madison's first librarian, presided over the acclaimed new James Library and began acquisitions that place the Madison Public Library among the best in New Jersey. The James Library (top left and bottom) combined vaulted ceilings, stained glass windows, and a decorative iron stairwell in the building's center. The structure recently was restored to much of its original glory by the Museum of Early Trades and Crafts.

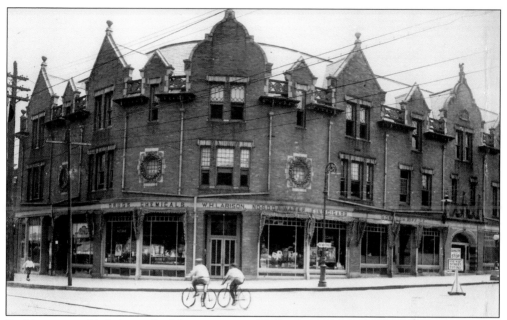

Seeking to establish a regular library income, Willis James built this business building and assembly hall across the street from the library. The James Building once housed large civic affairs and stage plays as well as the borough offices. For many years W.H. Larison's first-floor drugstore was a town landmark.

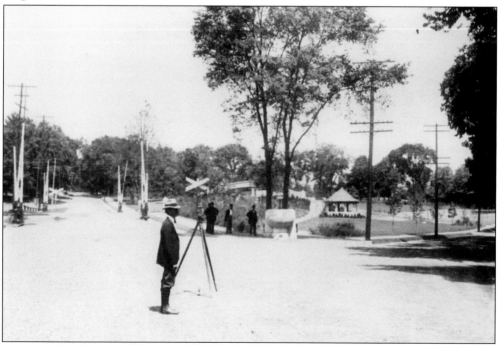

When the Delaware, Lackawanna & Western (Morris & Essex) Railroad elevated its roadbed through town just before World War I, James Park needed redesigning to fit the railroad blueprint. Surveyors studied the area west from Main Street to plan the revised park between Madison Avenue (Main Street) and Park Avenue.

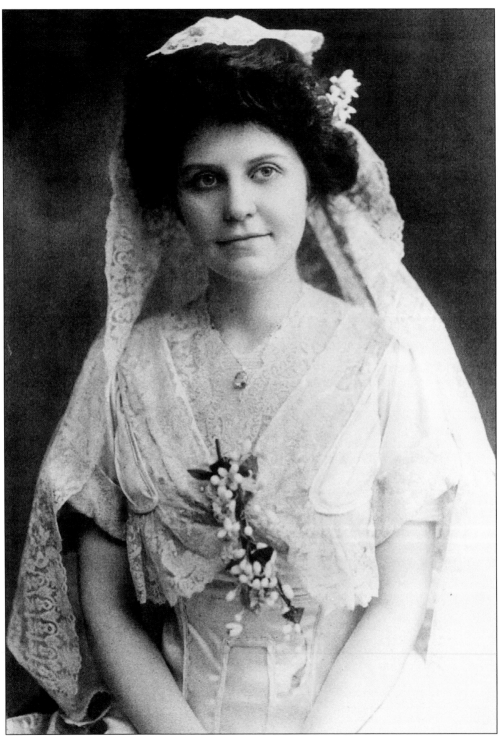

Geraldine Rockefeller, heiress to part of the huge Rockefeller holdings, posed for her wedding picture before her marriage on April 18, 1907, to Marcellus Hartley Dodge. When the newlyweds saw Madison for the first time soon after their marriage, they decided to live here.

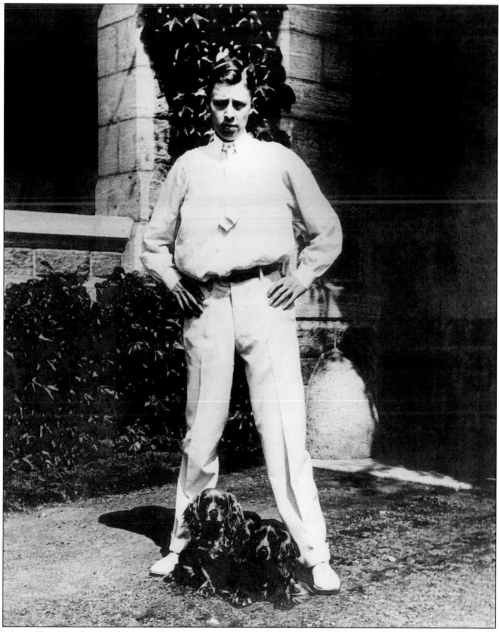

Marcellus Hartley Dodge posed with two favored pets, Mimi and Fuzzy, at his feet, soon after his marriage. He was a very wealthy young man in his own right. By age 21 young Dodge was sole heir to the Dodge fortune, made in copper and other commodities controlled by the Phelps-Dodge Corporation.

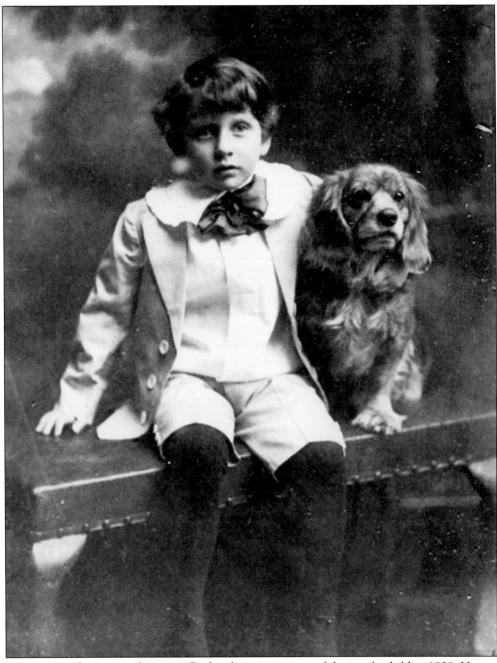

After a year of marriage, the young Dodges became parents of their only child in 1908. He was named Marcellus Hartley Dodge Jr. Shown here at about age six, he grew up learning to love the dogs and horses on the Madison estate. He died in August 1930, when his sports car crashed in Europe.

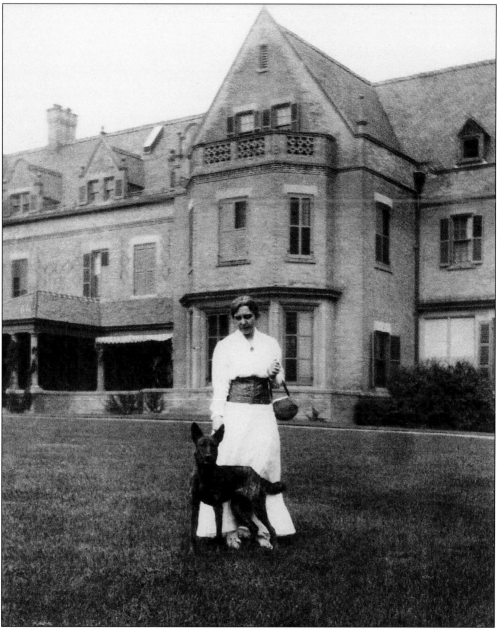

Young Geraldine Dodge in front of her 35-room house, "Giralda," with a favored dog, Hyphen. The Dodge complex consisted of two sections, "Giralda Farms" and "Hartley Farms," whose principal residences, nearly two miles apart, were linked by an 80-foot-wide, tree-lined corridor.

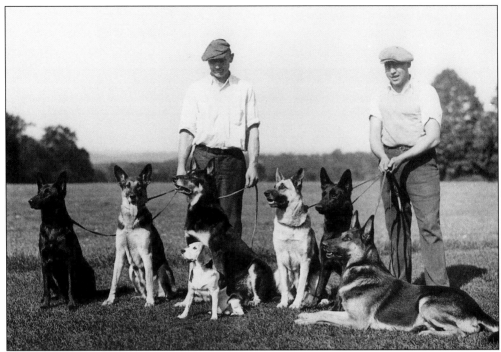

One of Mrs. Dodge's two main hobbies, art collecting and raising pedigreed dogs, led to breeding fine specimens for displaying in dog shows. Two of her dog handlers posed in the 1920s with seven Giralda Farms' prized animals, all but one of them German Shepherds.

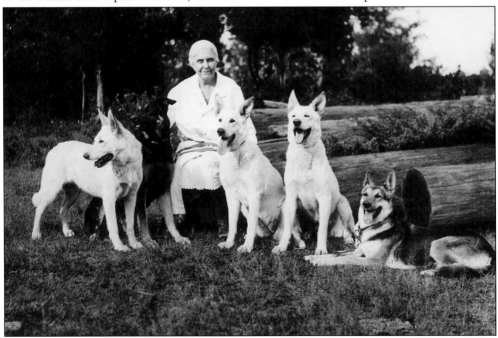

Mrs. Dodge was not an owner of animals solely for breeding purposes. Rather, she loved her dogs and had them near her often. Here, in a rare non-secluded moment, she posed with five favorites. The dogs appeared totally relaxed, as was Mrs. Dodge.

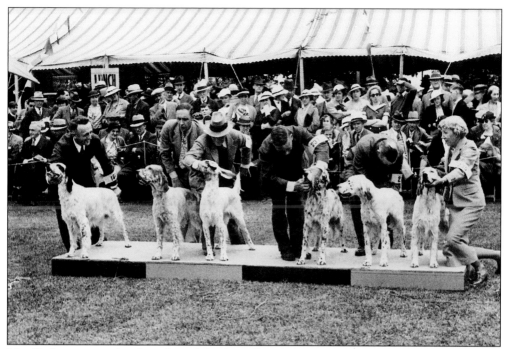

Mrs. Dodge organized and conducted the first of her internationally known Morris & Essex Dog Shows in 1927. Two of the annual shows (above and below) illustrate the intense competition for large cash prizes and engraved silver trophies. Thousands of visitors from all over the world came to Madison by trains, buses, and private automobiles to view what was described as "the largest one-day dog show in the world." The show was held for 30 years.

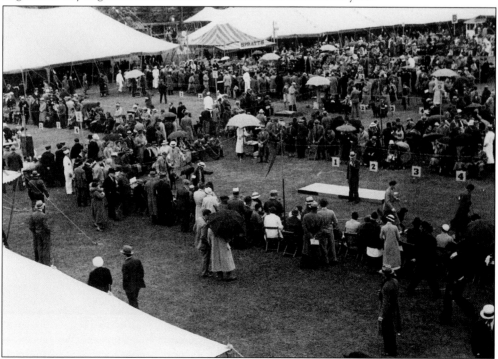

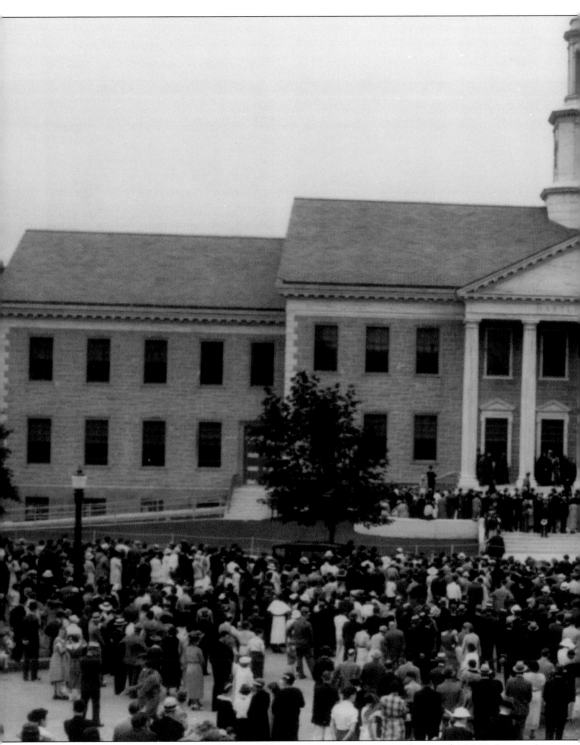

The Dodges made some small gifts to Madison over passing years, such as an $18,000 fire truck in 1921. Soon after, they donated a motorcycle and paid a mounted patrolman's salary for a year. After their son's death in 1930, the Dodges offered to build and furnish this $800,000 borough

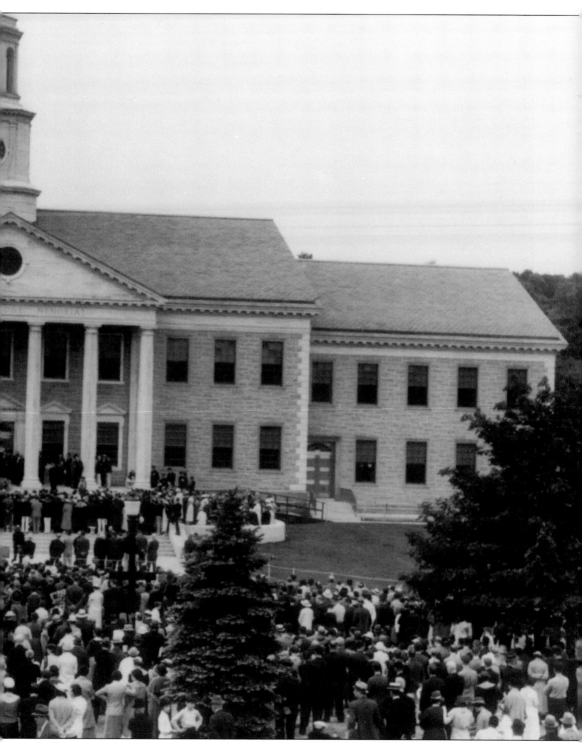

hall opposite the railroad station. Two thousand people attended the dedication services on Memorial Day 1935.

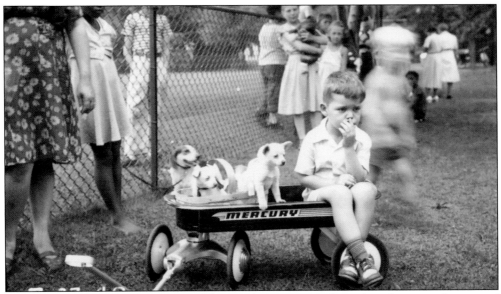

For many years, the Dodges were well-known by young people, at least by name, because of Dodge Field, built in the 1920s about three blocks north of the town center. Madison High School athletic teams used the field for about three decades. Each summer, thousands of children also flocked to Dodge Field for a "dog show" (above, not world-famed), or to display birds, goldfish, and cats in a pet show (below).

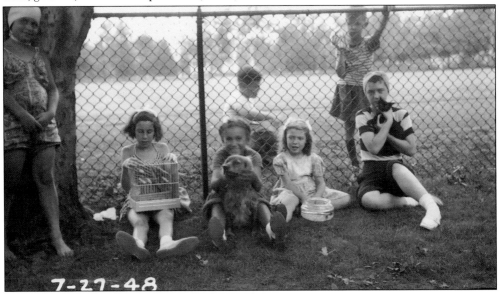

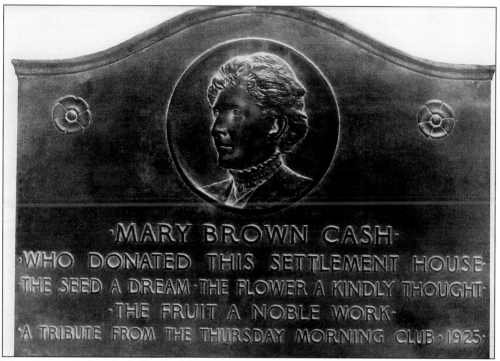

MARY BROWN CASH·
·WHO DONATED THIS SETTLEMENT HOUSE·
·THE SEED A DREAM·THE FLOWER A KINDLY THOUGHT·
·THE FRUIT A NOBLE WORK·
·A TRIBUTE FROM THE THURSDAY MORNING CLUB·1925·

Mary Brown Cash, a little-known Madison benefactor, is remembered mainly by this plaque in the Community House on Cook Avenue. In 1920, she left money in her will to underwrite the building "for the people of Madison as a whole." It was opened in January 1925.

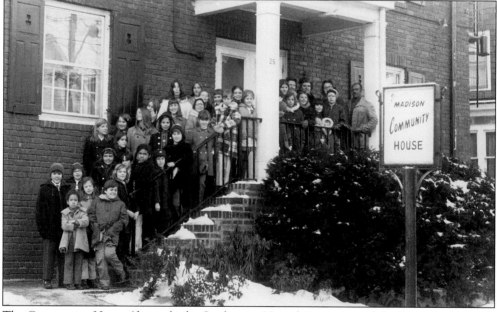

The Community House (formerly the Settlement House) is a project of the Thursday Morning Club, founded in 1896 and said to be the only women's club in the United States to own and operate a Settlement House. The building's interior has been altered but the exterior is little changed.

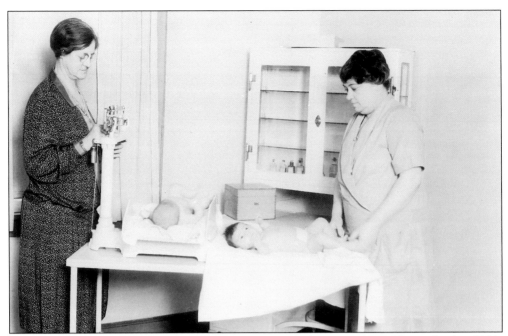

Children and family life always have been important at the Community House. In this 1920s photograph, Miss Cora Payn (left), known as the "Angel of Mercy," offered mothers important assistance in keeping babies thriving. Miss Payn was nearly always on hand at weigh-ins to offer help.

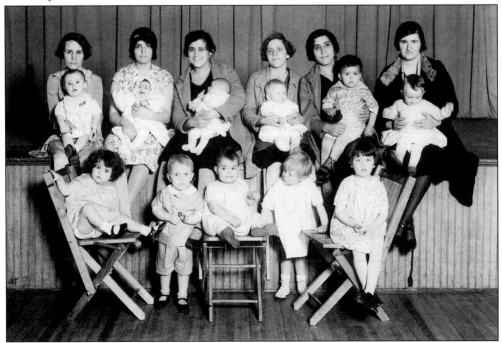

Another early Settlement House photograph included six mothers and 11 children who were benefiting from the program. Many of the children shown here grew up to participate in other of the facility's extensive programs, which ranged from babysitting classes to basketball games.

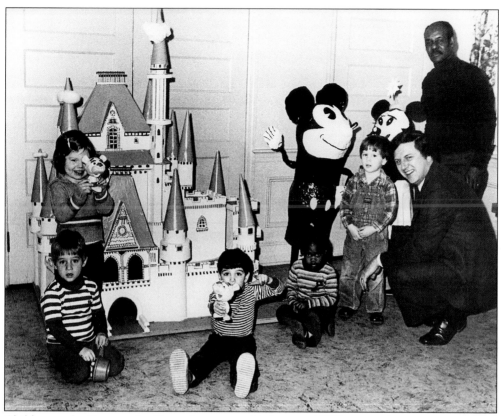

Children at the Community House (so renamed in January 1957) were either entertained (top) or provided the show (below). George Burroughs, longtime director, is in the upper right at a Mickey Mouse program. Looking on is Carl Fruehling. The costumed girls had just presented an original song-and-dance program on the house stage.

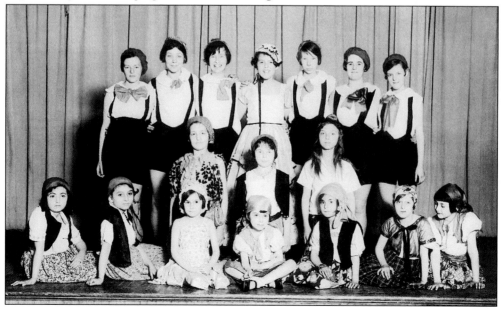

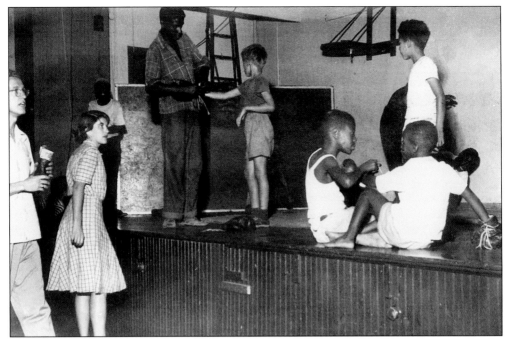

Youth participation could be active, as in the amateur boxers (above), or passive, as in the entranced audience (below). Thousands of boys and girls learned to dance, box, play basketball, sew, cook, and get along with other people in varied Community House programs meant to help them succeed in the world they would inherit.

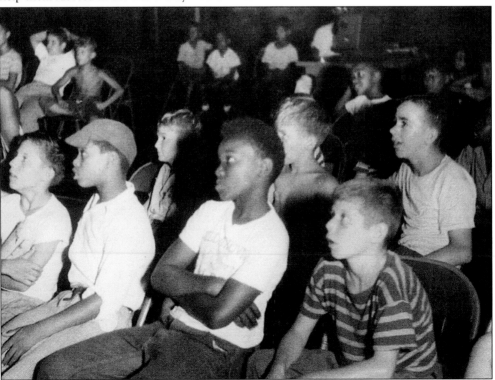

Five

An Elevating Experience

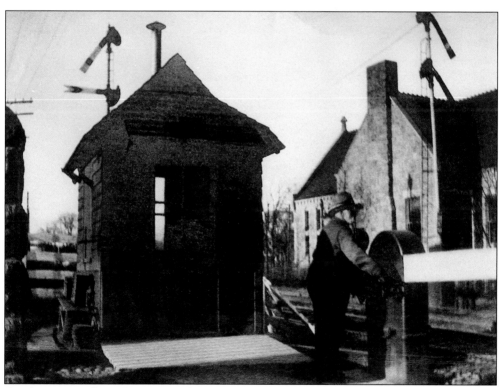

Gatekeepers, such as the man in this illustration, ruled the comings and goings of Madison residents when the twentieth century dawned. Madison then was completely on the level wherever horses, wagons, buggies, bicycles, or pedestrians crossed the railroad tracks. When trains approached, in darkness or in sunshine, gatekeepers quickly lowered long wooden gates to thwart careless track-crossers. By World War I, gatekeepers were gone, replaced by concrete arches that lifted tracks high above the streets.

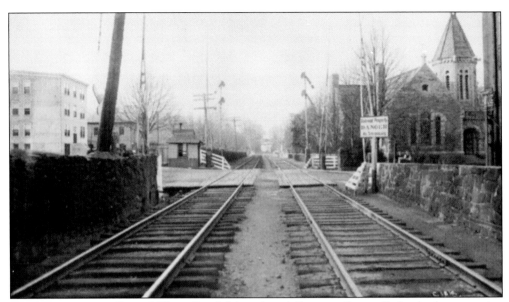

Two major streets, Green Village Road (above) and Prospect Street (below), show crossing gates in the up position. Green Village Road was a favored crossing. Prospect Street offered more challenges because it was the entrance area to industries (hay and feed, coal, equipment) served by freight trains. Note the wide boardwalks through the tracks that eased the way for vehicle wheels.

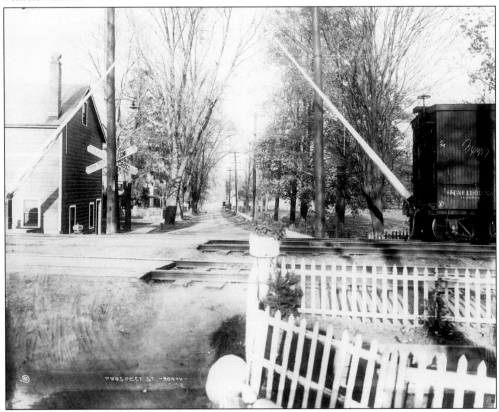

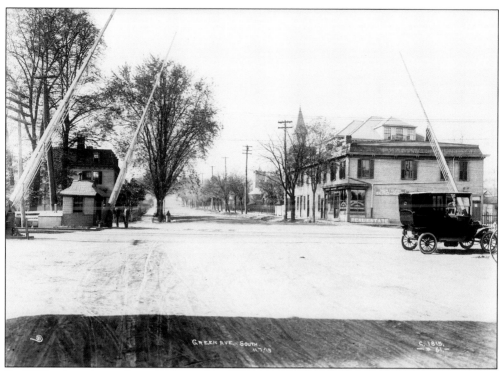

By 1913, when these photographs were taken, automobiles were an emerging traffic problem. Green Avenue (above) led southward from the depot past Joseph V. Keating's real estate office. The ground-level depot on Waverly Place (below) was in turmoil when commuter trains arrived in late afternoon. Waverly Place was (and is) the short block linking Green and Central Avenues.

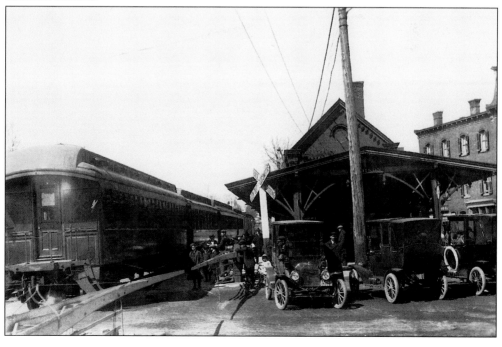

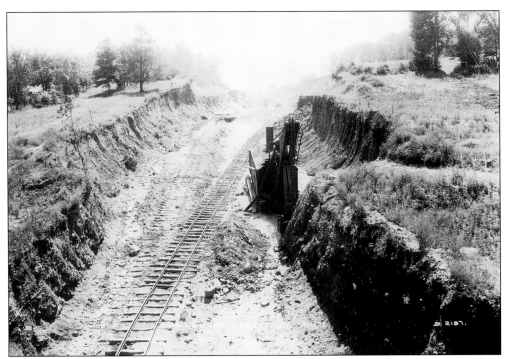

The railroad's elevation of the tracks began with blasting a two-mile long, 75-foot-deep cut through Union Hill (above) on the east side of town to level the tracks and eliminate a sharp curve. Swarms of workers, mostly immigrants, used steam shovels and hand tools to remove more than 600,000 cubic yards of dirt. In town, other crews (below) built temporary tracks to carry trains during the two-year project.

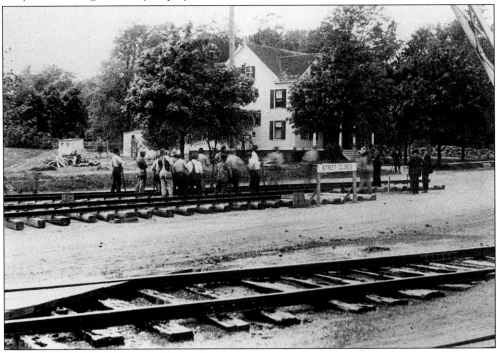

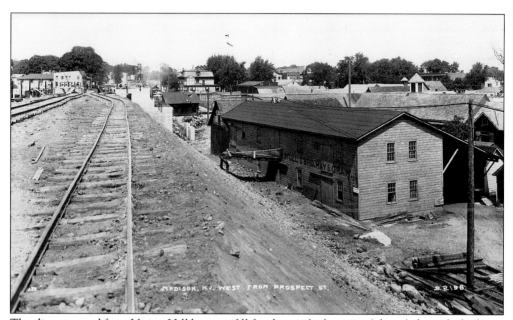

The dirt removed from Union Hill became fill for the track elevation (above) through the heart of Madison. Temporary tracks carried slow-moving, ground-level trains with little interrupted service. The beginnings of a substantial new depot can be seen in the distance. Below, a short train moves slowly past new depot footings under construction.

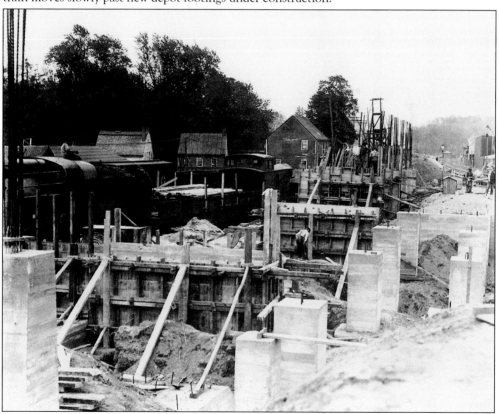

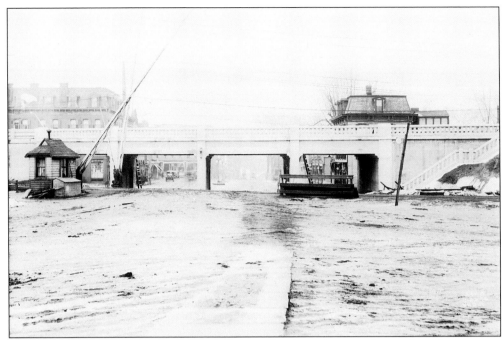

The elevated tracks of the future were nearly ready when photographs on these facing pages were taken in December 1915. Above, the Green Avenue overpass and the steps for eastbound trains were clear. From another angle (below), the Perlaw Building and the American House (both on Waverly Place) rose above the railroad. The old ground-level station had been torn down.

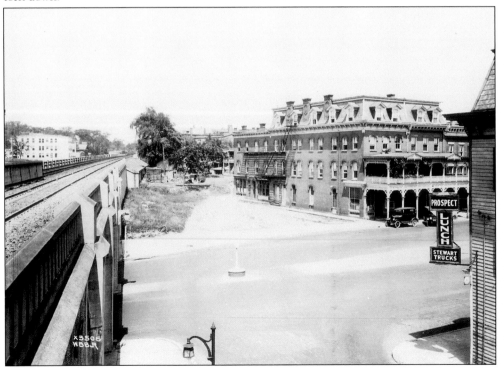

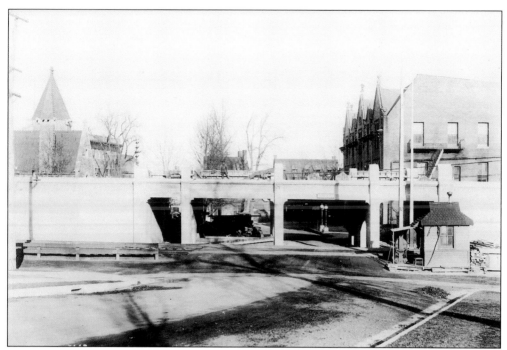

James Library, left, and the James Building, right, were visible at the Green Village Road overpass (above) in December 1912, as were several Main Street buildings. The gatekeeper's house still stood. More impressive was the overpass (below) where Main Street became Madison Avenue. One little boy watched a lone steamroller driver put finishing touches on the intersection.

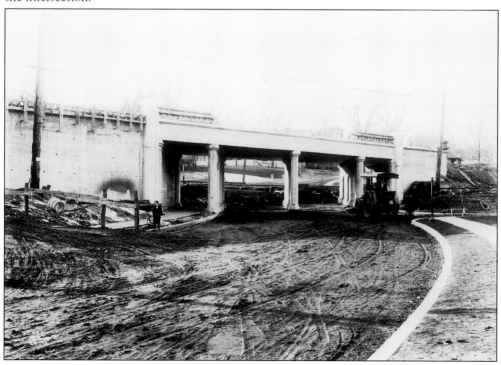

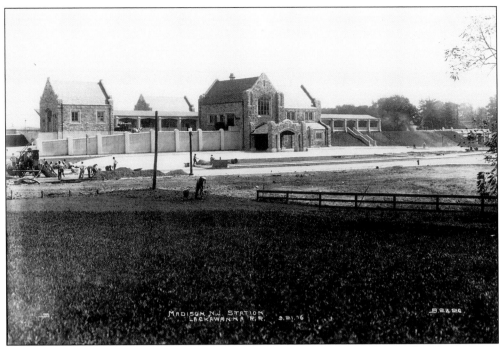

As elevation neared completion, Mrs. D. Willis James led residents who sought a new station that would reflect Madison. The borough council floated a $159,000 bond issue for the stone station (above). Finished in 1916, it was Collegiate Gothic, a tribute to Drew University. The steeples of Green Avenue School and St. Vincent's Church dominated the skyline beyond the plaza.

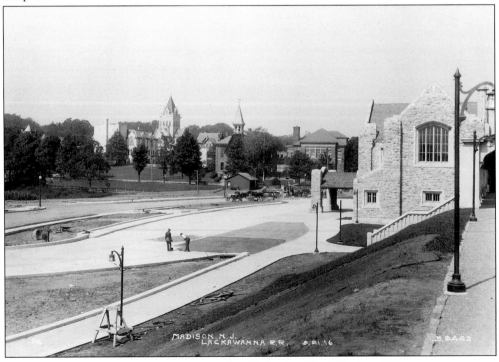

Six substantial houses along realigned Kings Road (above and below) were relocated to provide open space across from the new station plaza. St. Vincent's Church steeple can be seen above and the smaller steeple of Green Avenue School appears in the photograph below. Two houses were moved to Central Avenue, two to Belmont Avenue, and one each to Central Avenue and Green Village Road. About twenty years later, this area became the site for the Hartley Dodge Memorial Building.

A major change brought by the track elevation was the creation of Lincoln Place, which paralleled the railroad between Waverly Place and Prospect Street. The post office and movie theater are now on Lincoln Place. The house on the right stood where Lincoln Place went west from Prospect. It was demolished, with debris being removed by horses and wagons. The building with the gambrel roof was restored and is now an office of Weichert Realtors.

Six

Get a Horse!

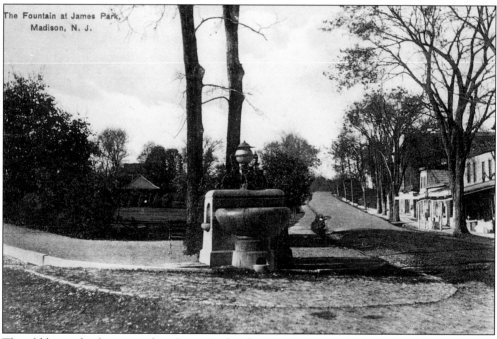

The old horse drinking trough at James Park, where Park Avenue (right) and Madison Avenue met, saw major use before automobiles became America's dominant means of transportation. On hot summer days, the area around the trough was filled with steeds, wagons, and wagon drivers. Horses enjoyed a high point of use between about 1885 and 1910, when the borough had many estates, large farms, and small businesses, all of which depended on real horsepower. Horseshoers, livery stables, and store delivery wagons also swelled horse traffic on crowded streets.

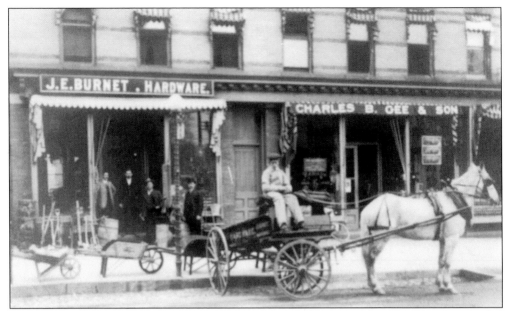

Delivery to homes in early-twentieth-century years inevitably was via a horse and wagon, whether the product was milk, bread, coal, groceries, or fertilizer. A typical Main Street merchant, J.E. Burnet, delivered his hardware products in a store wagon drawn by Harry the Horse. In this photograph, employee Fred McPeek was in the driver's seat.

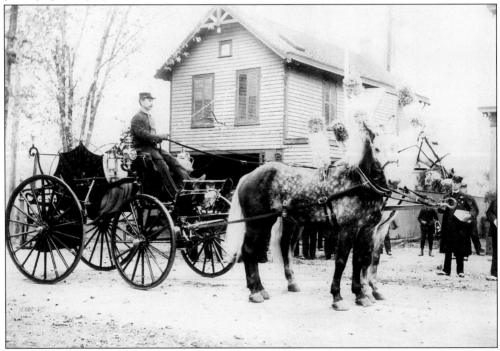

Pat Dougherty, popular fireman, lightly reined in his department's sturdy horses as they prepared to pull a light fire wagon in one of Madison's many parades of the 1890s. The wooden firehouse on Central Avenue, built in the 1870s, provided the background. Other firemen waited to follow the team and wagon.

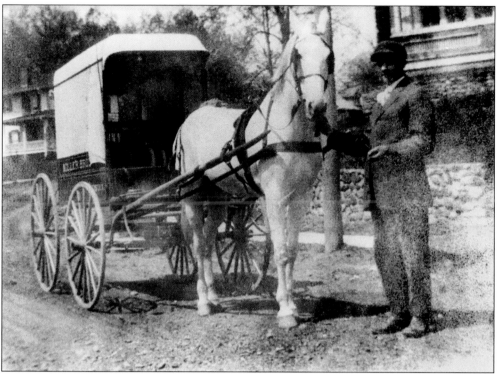

Typical delivery wagons of the early 1900s were easy-riding vehicles such as the one above that carried Miller Brothers' "choice meats, game and poultry" to borough households, or sturdy wagons like the one below that S. Tuttle's Son & Company required to carry coal and wood. Coal wagons were numerous; the fuel was vital in homes, public buildings, businesses, and greenhouses.

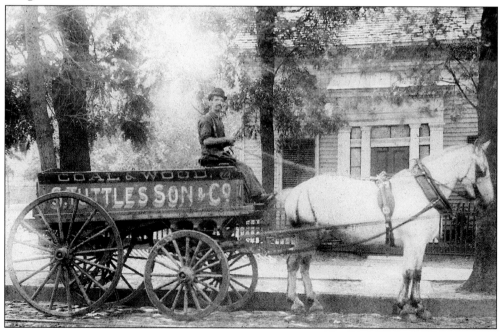

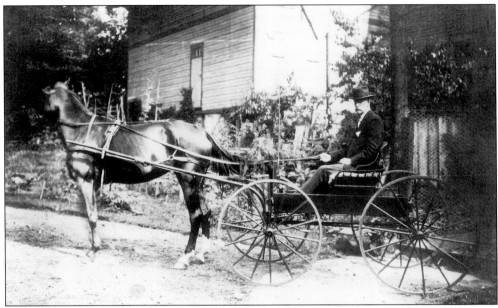

Elegant one-horse equipages carried townspeople everywhere—to the railroad station, to local businesses, to baseball games, and local parks. The carriage (above) was ideal for doctors on their rounds or for young lovers on afternoon jaunts. The surrey (below) had curtains to drop during showers, rear fenders to turn mud aside, and a lamp for night driving.

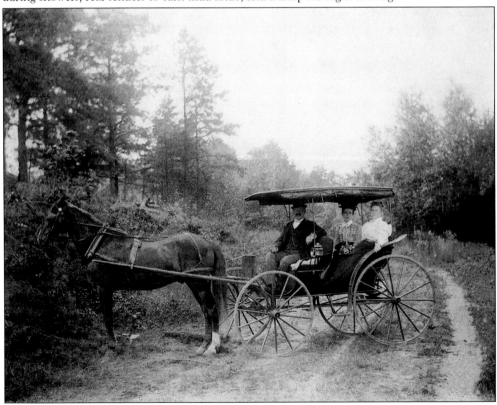

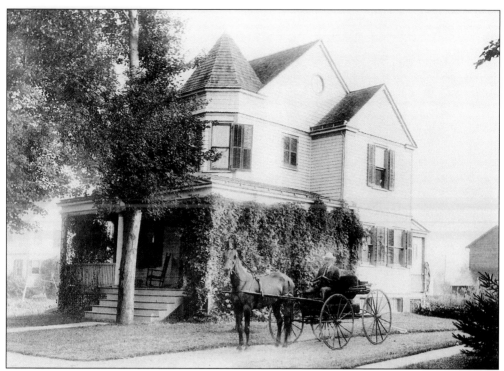

Horses and buggies were as familiar in family photographs as homes and people. Above, an unknown man shows off both his horse and his house at the corner of what are now Brittin Street and Alexander Avenue. Below, Russell Cornell (in the buggy), his horse, and his wife, Charlotte (on the porch), posed in 1881 for what might be interpreted as a family portrait.

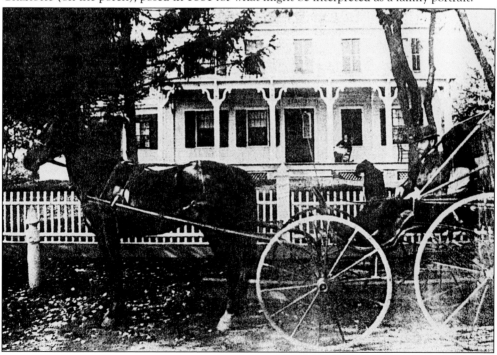

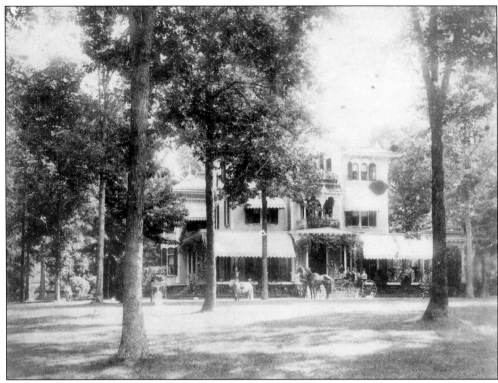

Madison's wealthy families all had several (and occasionally, many) horses and carriages. The photograph taken in about 1900 of the Charles W. Decker house (above) at 307 Madison Avenue naturally included a horse and buggy waiting in the driveway. Horses also were the motif when Edward P. Holden Jr. (below) played with his pony in 1901 outside the stable of his grandfather, James A. Webb.

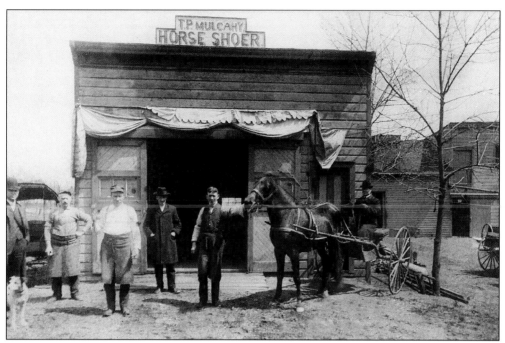

Everything pertaining to horses could be found in Madison. Most important were the horseshoers, such as T.P. Mulcahy (above), who had his establishment on Park Avenue, and Edward Hinch (below), whose blacksmith shop was on Cook Avenue. John Mulcahy continued his family's business, founded in 1839, until 1968.

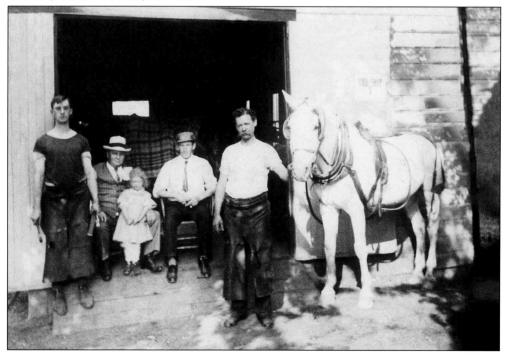

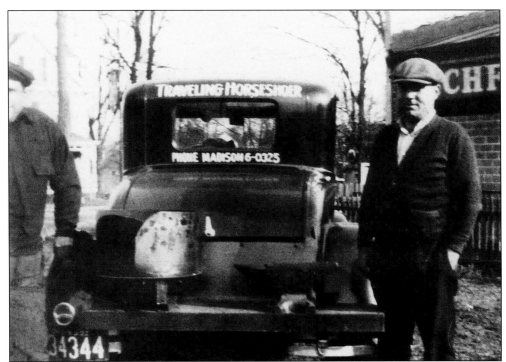

Conversion to the automobile age was swift. John Mulcahy (above) became a "Traveling Horseshoer" in the 1920s by driving his small coupe to surrounding farms and estates. Perhaps the ultimate transition photograph (below) shows past and present side by side on Central Avenue between Main Street and Cook Avenue. L.L. Taylor, horseshoer, was on the right, next door to the garage where David S. Ely opened a Chevrolet dealership before World War I.

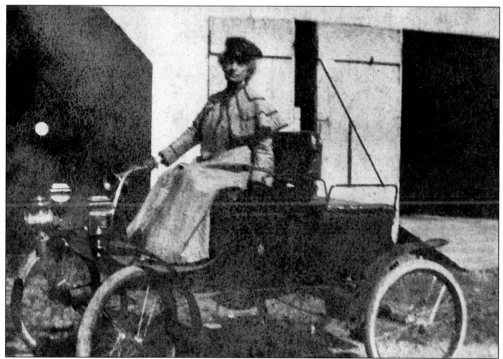

This little car, quite possibly the first in Madison, was driven throughout the town by one of the community's distinguished ladies, Julia (often called Julie) Davis. Note that it had a tiller rather than a wheel for steering. Mr. and Mrs. James C. Bellingham (below) took proper pride in their sporty and expensive 1920s roadster. The car and the Bellinghams were a familiar sight, both around town and in parades.

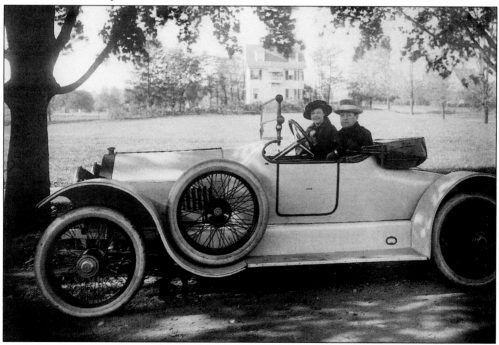

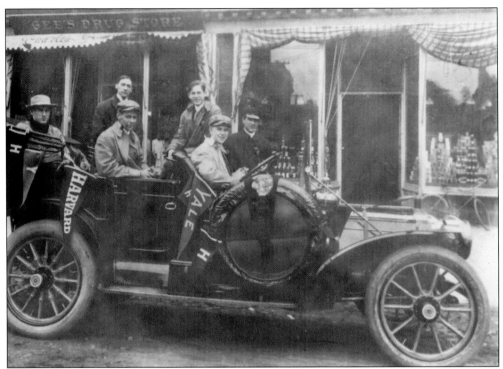

The Harvard and Yale pennants were impressive, but these Madisonians were headed on May 10, 1911, for boat races at Princeton. The *Madison Eagle* was amazed that the car had been driven "over 5,000 miles in five months." The sports-minded group included Curtis and James McGraw, Ted Steadman, Jack Humbert, Andy Gee, and Fred Douglass.

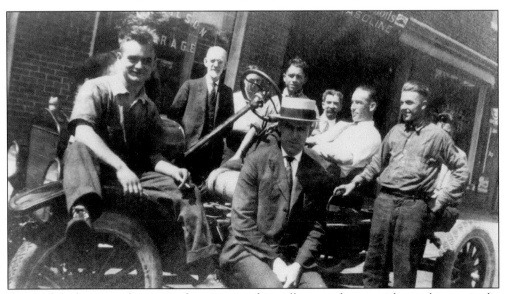

Automobile fever struck groups of young men from all parts of town with equal intensity by the mid-1920s. Here several unidentified car aficionados gathered outside I.R. Wilson's Ford agency and garage on Kings Road to enjoy and to work on this stripped-down automobile. Wilson, known as Ike, was a popular, active Madison figure.

Seven

The Heart and Pulse

Visitors entering or leaving Madison in about 1910 saw the backyards of borough homes that often displayed long strings of wash to emphasize the cleanliness of housekeepers. This scene looked across the ground-level tracks toward the rear entrances of Park Avenue in about 1900. Railroads then were any small town's link with the outside world. Little boys yearned to be locomotive engineers and housewives set kitchen clocks by train whistles.

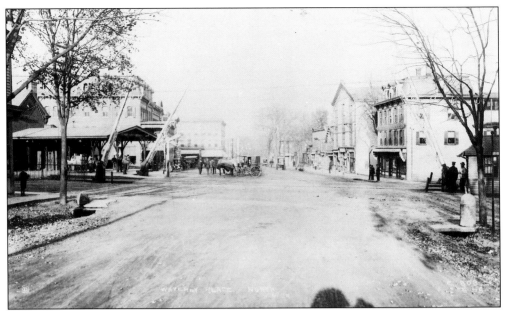

The gateway to downtown, linking the depot and Main Street, was (and is) Waverly Place, shown here looking north. Waverly was widened in the 1870s by moving buildings back from the original street. Despite moderate alterations, the west side of the street has changed little in structural appearance in more than century.

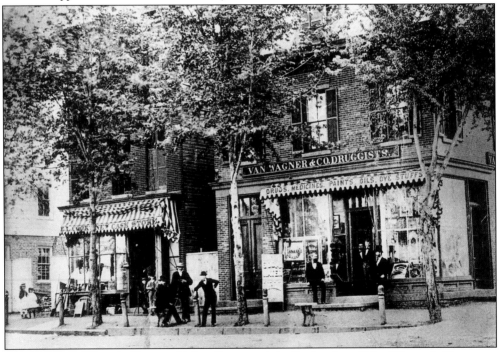

This corner at Waverly Place and Main Street, originally the site of Van Wagner's Drugstore, has long been Madison's centerpiece. The third floor was added after an 1879 fire. The corner store now houses Rose City Jewelers, whose owner, Joseph Falco, restored the building, thus leading the move to restore Madison's downtown.

In the 1890s, communication with the outside world came mainly through the post office (above) at 52 Main Street, where townspeople met to pick up mail and exchange gossip. By 1912, the camaraderie of the post office slowly faded as uniformed postmen John Talmadge, Milton Megargel, and A.J. Harmon (below) delivered the mail. Modern mail service arrived when the new post office was opened on Lincoln Place in 1936.

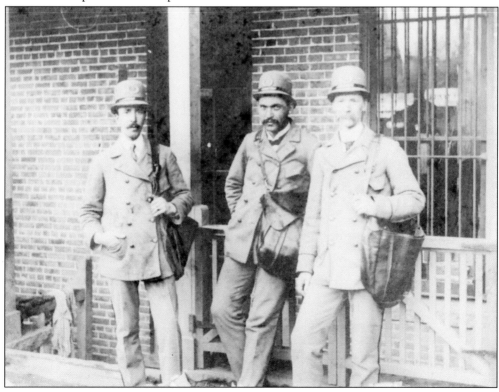

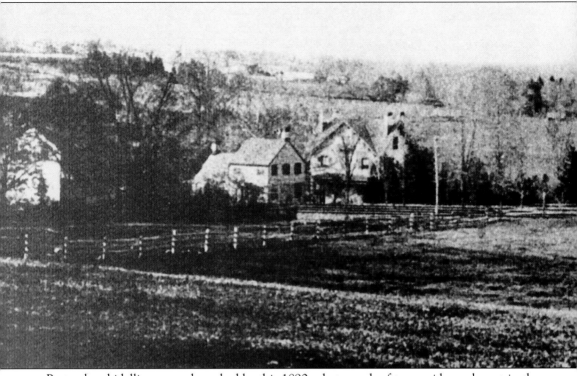

Pastoral and idyllic are words evoked by this 1890s photograph of two maidens who sat in the hilltop meadow sloping northward from Kings Road to Main Street (known as Morris Turnpike

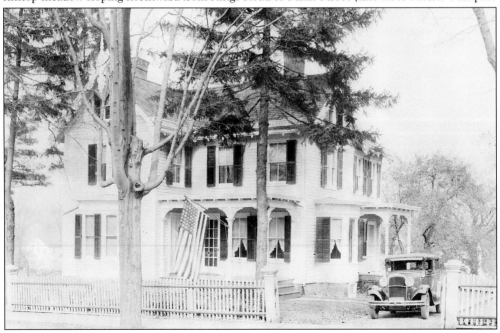

Many prime residences had been built along Main Street, such as the Hastings-Bertrand House at 246 Main Street (above). This photograph was taken in 1941. The house has been torn down to make way for commerce.

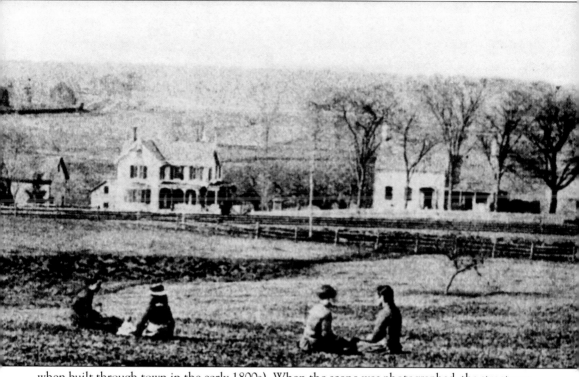

when built through town in the early 1800s). When the scene was photographed, the street was truly main—Madison's pulse of commerce had shifted to the roadway long before 1880.

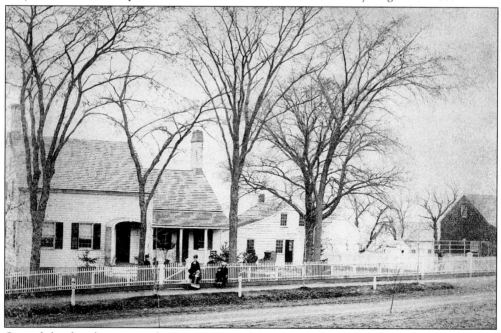

One of the first houses on the Morris Turnpike was built in 1802 by Jonathan B. Bruen, a member of one of Madison's earliest families and a founder of Madison Academy. The house and outbuildings, easily found in the scene above, now include several small businesses.

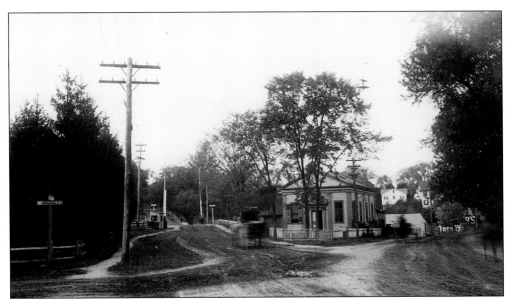

Main Street's western edge after the Morris Turnpike completion in 1802 became present-day James Park. Park Avenue veered right, and Main Street, left. At the point was the Presbyterian Lecture Room, later known as the Sessions House, built in 1851. After 1888, it housed town offices for nearly 20 years.

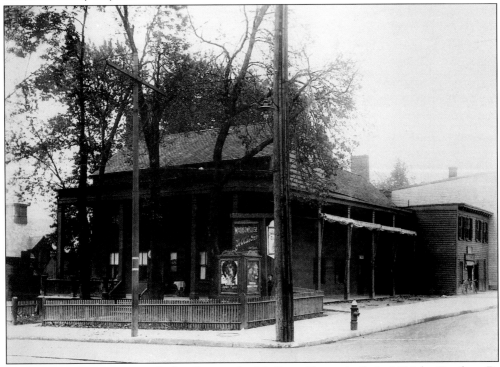

Madison's earliest center undoubtedly was the Madison House, built in 1819 by Stephen D. Hunting on the southeast corner of Waverly Place and Main Street. It entertained the great, the near-great, and most other townspeople for nearly a century. In this *c.* 1910 photograph, it displayed program posters for the nearby movie house.

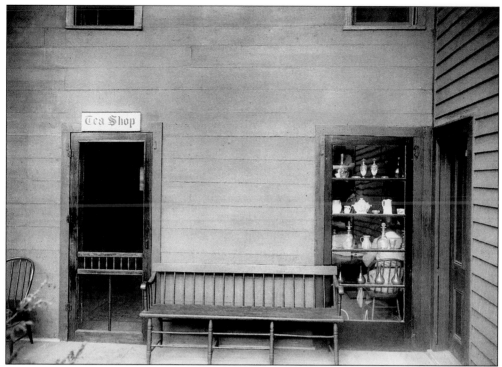

Attractions in the Madison House ranged from the simplest of pleasures, such as trading gossip and news on porch benches (above), to the possibility of business breakfasts or lunch in the "Tea Shop," where female points of view allegedly were heard. The dining room (below) also was ample enough for festive dinners and other major social gatherings.

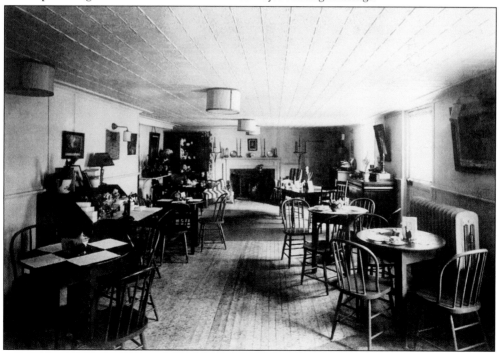

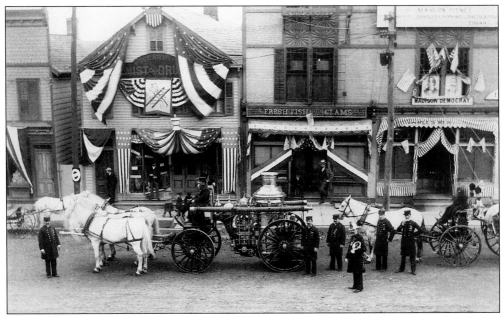

These two photographs center on basic irony: both were taken at nearly the same place. All was serene on the east side of Waverly Place (above) in the fall of 1894, when posters urged votes for Congressman Mahlon Pitney. The bedecked building was C.H. Benjamin's Real Estate and Insurance office. Firefighters were on the scene again in 1914 (below) when Fagan's Hall was destroyed by one of the town's biggest fires.

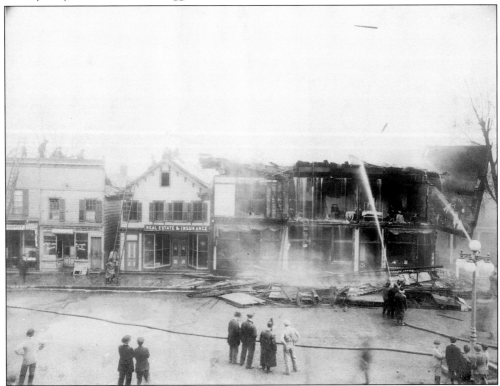

One of Madison's initial policemen (possibly the first) was Marshall Frederick S. Burnet (above left), who also was overseer of the poor. Prisoners, if any, were housed in the jail (above right) beside the Session House at Main and Park. Early in the twentieth century, the police department was moved to this wooden headquarters on Central Avenue (below), where the photograph was taken in 1925. The department then had ten officers, a police car, and a police motorcycle.

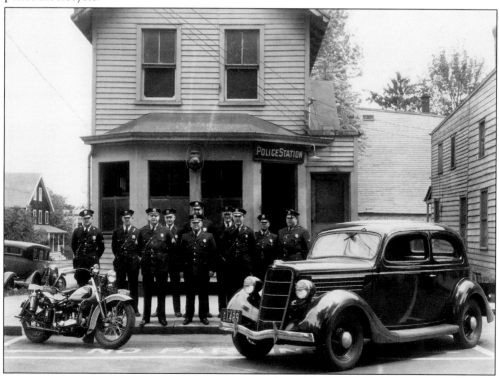

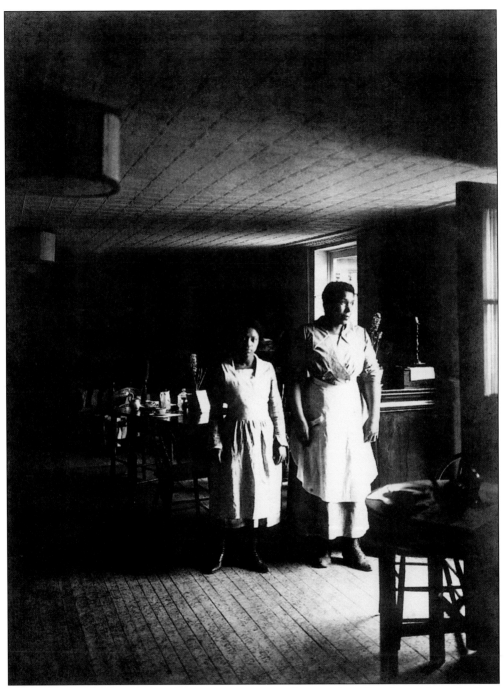

The names of these young working women are not known, but they learned much about Madison as they peered outward from the Madison House dining-room door to see the ever-shifting action on Waverly Place. The people changed but the action continued. Note the worn wooden floor and the tin ceiling, elegant in the days before World War I.

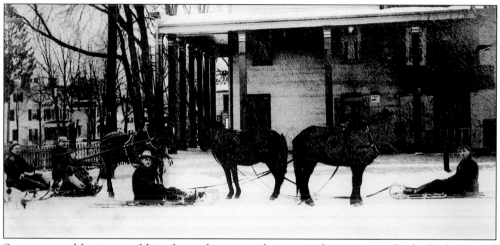

Snow stopped business cold in the early twentieth century, but anyone who had a horse and sleigh, toboggan, or sled (above) could show off outside the Madison House. Looking on (below) from the sidewalk were bemused Police Captain Fred Johnson, Madison House owner John McGrath, Thomas Rhedican, and a man known only as "Conroy."

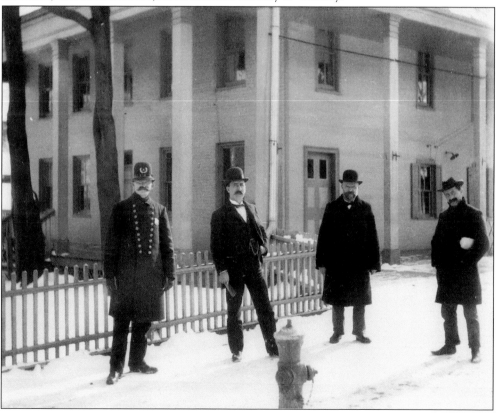

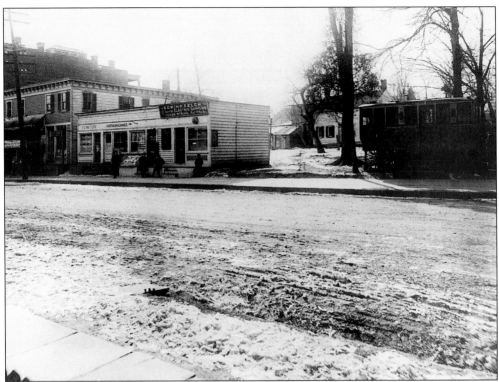

Any rain or snow made Main Street a challenge in the 1890s. On the south side of muddy Main (above), westward from the Brittin Building, were a laundry, furniture store, shoemaker, electrical supplier, and the Whitehouse Cafe lunch wagon. Little seemed to bother the vigorous young woman (below) who pedaled her two-wheeler westward on Waverly Place shortly before World War I.

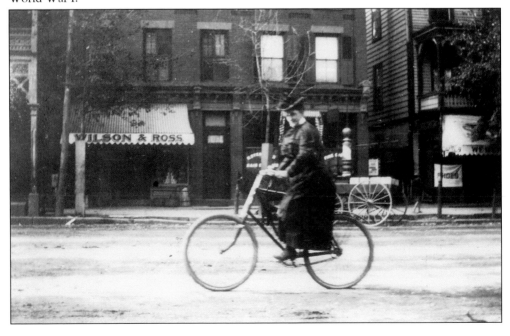

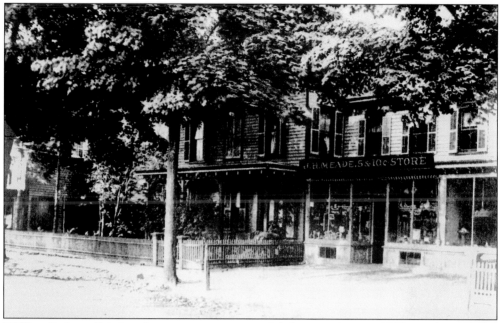

William Jackson Brittin, whose ancestors came to Madison in the year 1800, was born in this Main Street house on April 9, 1816, and lived there until he died in September 1897. After his death, borough shoppers frequented the site because it became the location of Meade's 5&10¢ Store.

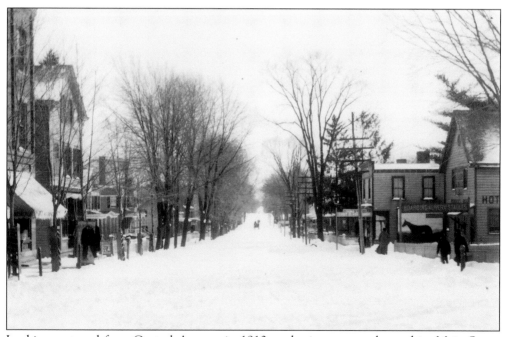

Looking eastward from Central Avenue in 1910, early risers saw a clean white Main Street created by an overnight snow. The snow and the unusual absence of wagons and pedestrians made it possible to realize how towering were the trees that bordered the road.

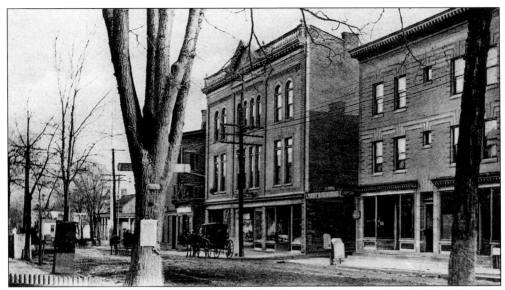

In the late 1890s, when vacationers spent leisurely days in Madison, the "wish-you-were-here" postcards featured Main Street. This view focused on the three-story Brittin Building with a buggy in front. The Madison House can be seen in the distance, just left of the large tree.

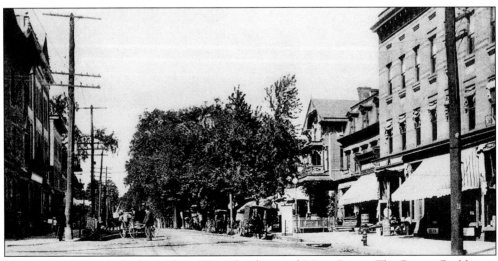

This postcard view looked west from Waverly Place and Main Street. The Burnet Building is on the right and next door is Meade's 5&10¢ Store. Delivery wagons of Main Street merchants lined the street and fully leafed-out trees cast pleasant shadows over the roadway.

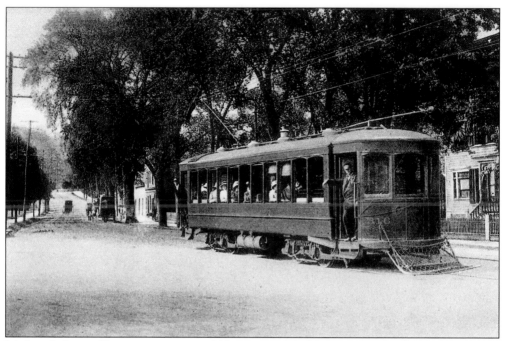

Madison's first trolley came to town in February 1912, riding on ice-covered rails. On a much later and much sunnier day, Walter Raymond, motorman, showed off his trolley (above). Trolley tracks stretched eastward toward Newark (below), passing on the right the town's first movie house, identifiable by banners over the sidewalk that announced coming attractions.

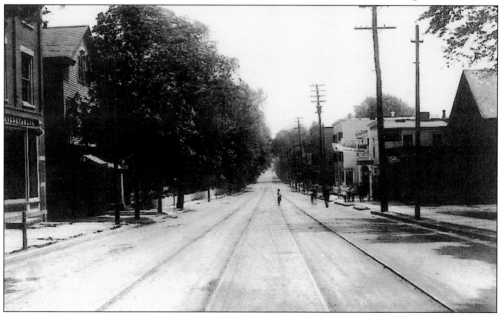

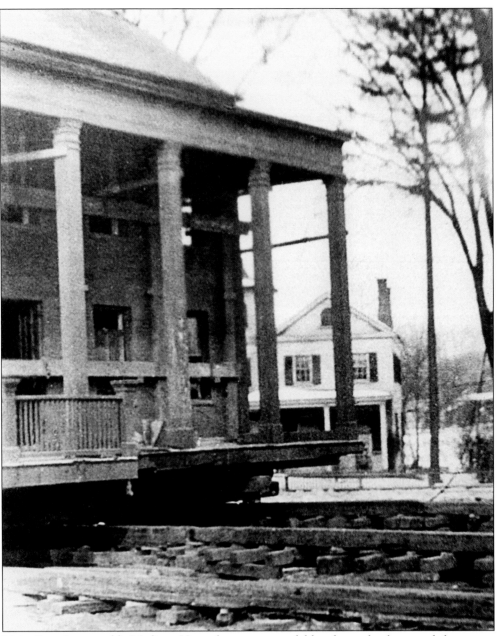

Main Street's venerable Madison House became expendable when a bank wanted the corner in 1922. The house was pulled off its foundation during the winter of 1923, placed on a flatbed with trolley wheels, and towed eastward to a new site. The newly formed Madison Historical Society raised money for the move. The move disrupted 1923 trolley service for several weeks. The building survived as a series of "Bottle Hill" restaurants until another bank bought the badly deteriorating structure, tore it down, and replaced it with a replica that served as a bank.

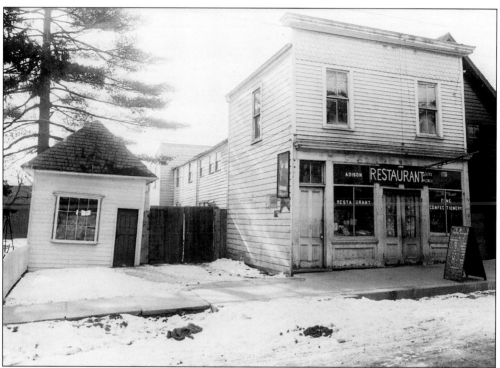

Contrasting architectural styles on Main Street ranged from that of Granata's Restaurant (above)—possibly best described as "early-pseudo western frontier"—and the Gee Building (right), a traditional three-story brick structure that in early days housed the First National Bank and the *Madison Eagle*, which both faced Main Street.

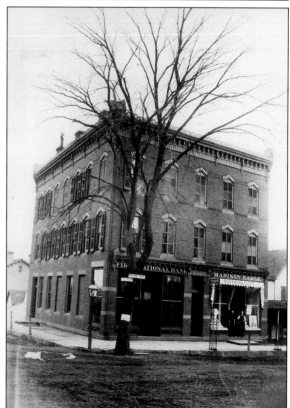

No eating place in Madison or nearby was more frequented by young people and working people of the 1930s and 1940s than Goumas's Diner on Main Street. The Goumas family began the eatery in their home (above) in 1926 and soon after enlarged and remodeled the eatery. The menu featured everything from real goulash to huge jelly doughnuts. The Nautilus Diner, much enlarged, now occupies the site.

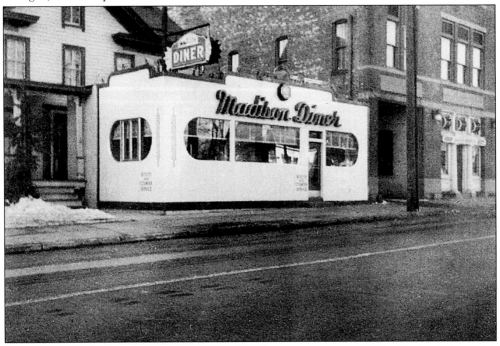

Eight

Life Goes On

One of Madison's moderately known products was Kluxen wine, which in this illustration combined wines and roses on a label from the 1920s. The Kluxen family came from Schleissberg, Germany, in 1865 and began producing sacramental wines. Those wines and the beginnings of the huge local commercial rose production arrived on the Madison scene at about the same time. Both declined after the 1950s. The winery was demolished in 1973. The last rose range in the borough was closed in 1984. But life went on.

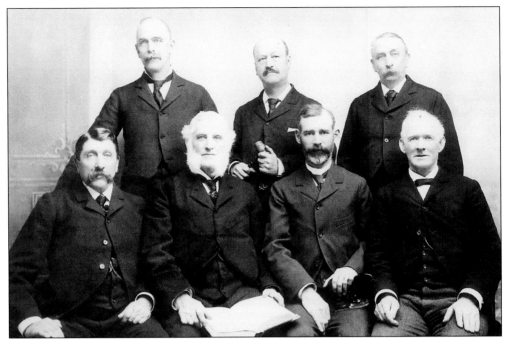

After the unincorporated town of Madison broke away from Chatham Township on Christmas Eve 1889 to become Madison Borough, voters elected their first mayor and council (above) on January 14, 1890. Two of the borough's best-known mayors were James P. Albright (below right), Madison's first mayor, and Elizabeth Baumgartner (below left), the borough's first woman mayor, elected in 1979. Both were Democrats in a solidly Republican borough.

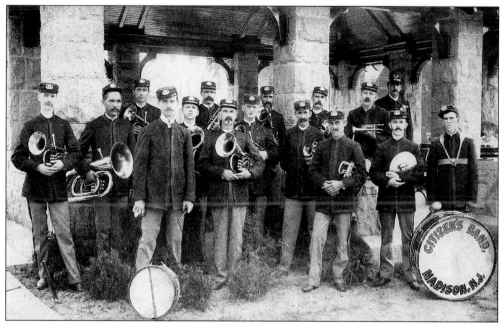

Music has always been a vibrant local force. Two of Madison's early-twentieth-century groups were the Citizen's Band (above) and the Madison Fife and Drum Corps (below). The Citizen's Band was a solid, old-fashioned brass band. The corps, on the other hand, blended fifes with its drums.

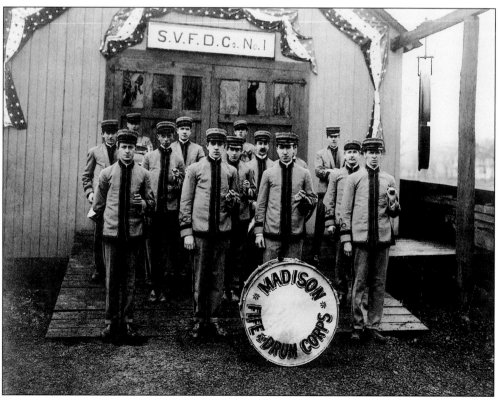

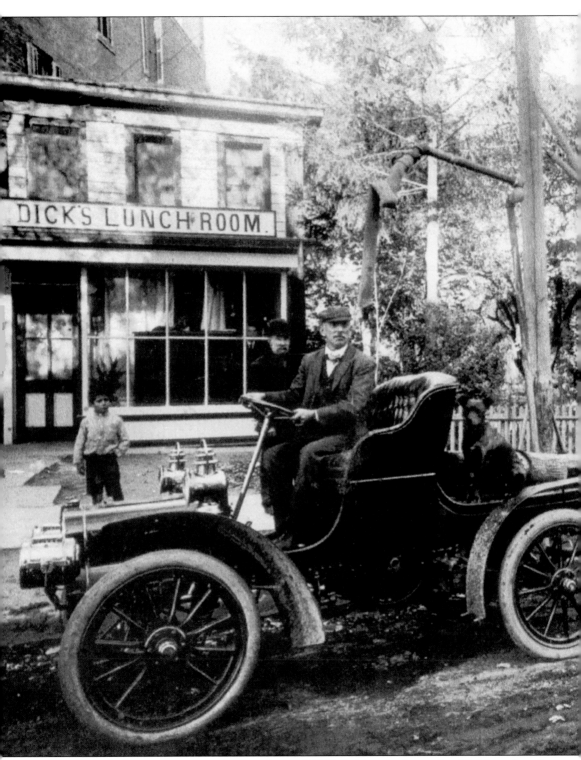

The first telephone service came in the winter of 1883, linking the borough with Newark and the outside world. When the old poles and wires were replaced in the early twentieth century,

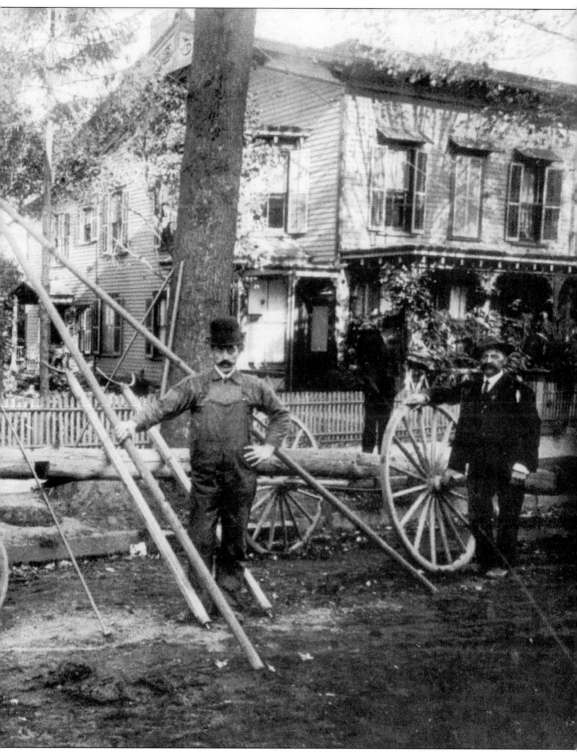

the replacement poles were hauled along Main Street behind a sporty runabout. One of the new poles has just been set next to Dick's Lunch Room.

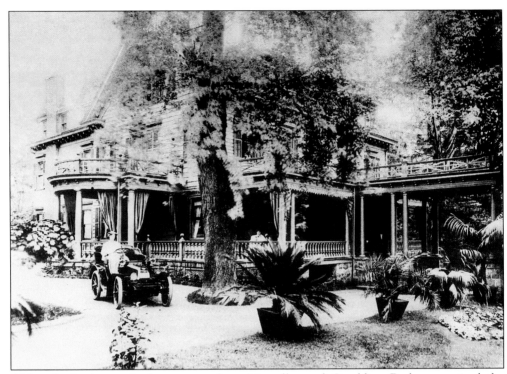

Although the largest landowners—such as Marcellus and Geraldine Dodge—received the most attention in the press, other fine estate homes could be found in many sections of town. "Rosedale Villa" on Main Street (above) survives as today's Elks Club. Wisteria Lodge (below) was linked to the prominent nineteenth-century Gibbons and Lathrop families. Each helped develop and shape the character of modern Madison.

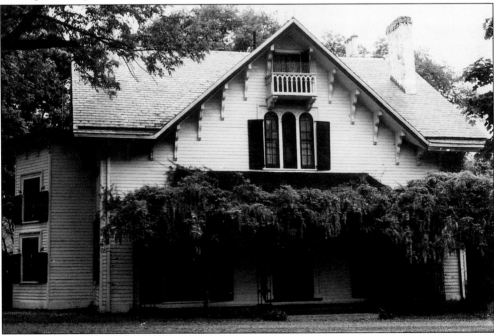

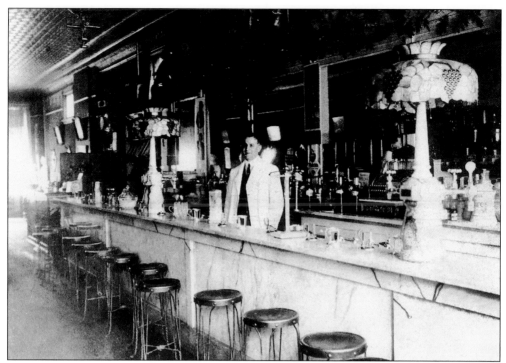

One of Madison's strongest immigrant groups came from Italy, mainly to provide much-needed labor on farms and in homes. As the years passed, many of these immigrants entered local trades or created new businesses, such as Andy Lusardi's confectionery at 51 Main Street (above). They also formed new clubs and associations, including the Loggio Christopher Columbo (below).

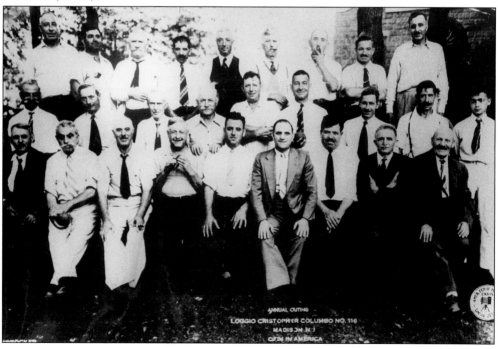

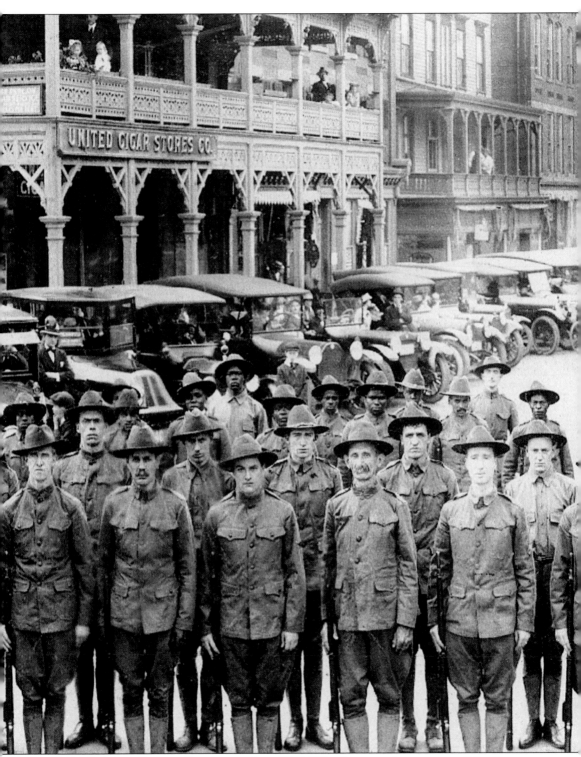

Madison's Home Defense Guard, star of pre-World War I ceremonies, was one of the first town groups to reach out to the multi-ethnic population. This portion of a 4-foot-wide photograph

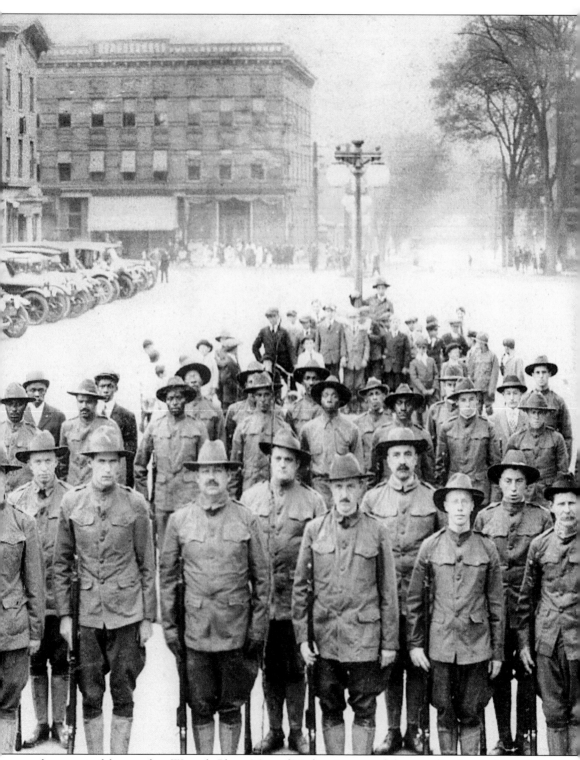

shows part of the guard on Waverly Place. Most of Madison's automobiles were lined up in front of ornate buildings on the street's west side. Minus the balconies, all of the buildings still stand.

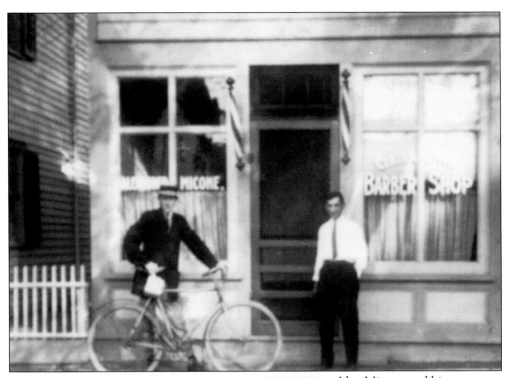

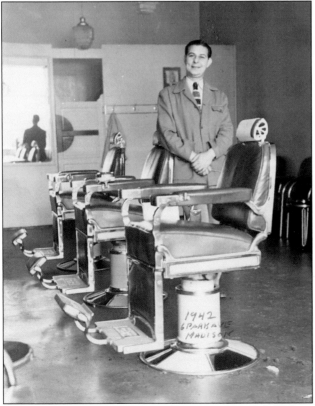

Alex Micone and his barbershop, built on Central Avenue in 1911, became longtime Madison institutions. Alex opened his first shop on Waverly Place in 1909, moved to his Central Avenue shop two years later, and cut hair there until he retired in 1988. He had many apprentices who became leading barbers, including Peter Cattano (left). Peter opened his own shop on Park Avenue in 1942 and became one of Madison's popular haircutters.

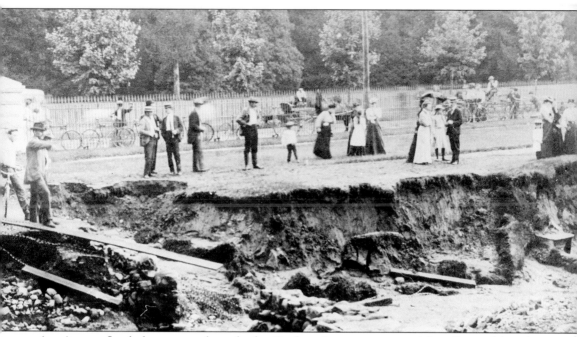

An August flood that swept through the Presbyterian cemetery on Main Street (above) ripped dozens of coffins from the ground and scattered them along the newly created gully. Most of the bodies were identified and reburied but a few were not fully identified. One of the unusual gravestones is that of Gypsy King Naylor Harrison (below left), who died in 1928. His photograph is on his tombstone (below right).

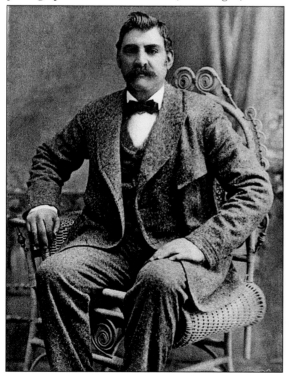

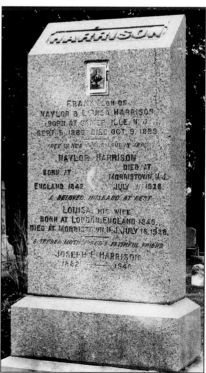

HARRISON

FRANK SON OF
NAYLOR & LOUISA HARRISON
BORN AT SOMERVILLE N.J.
SEPT. 6 1880 DIED OCT. 9 1883

NAYLOR HARRISON
BORN AT DIED AT
ENGLAND 1842 MORRISTOWN N.J.
 JULY 1 1928
A BELOVED HUSBAND AT REST

LOUISA HIS WIFE
BORN AT LONDON ENGLAND 1849
DIED AT MORRISTOWN N.J. JULY 16 1926
A TENDER MOTHER AND A FAITHFUL FRIEND

JOSEPH E. HARRISON
1882 1946

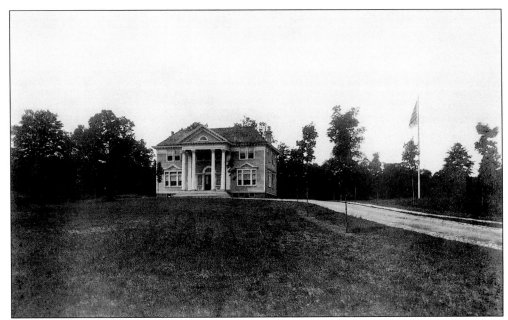

Madison Academy's new home on Green Village Road, as it appeared in about 1908 (above), was the educational base for children of Madison's elite. When the academy's boys and two faculty members (below) posed, hats were de rigueur for everyone. One student wore a derby, others wore caps. Note the baseball gloves; the small glove held up by a boy in the front was a fielder's mitt, not something for warmth or style.

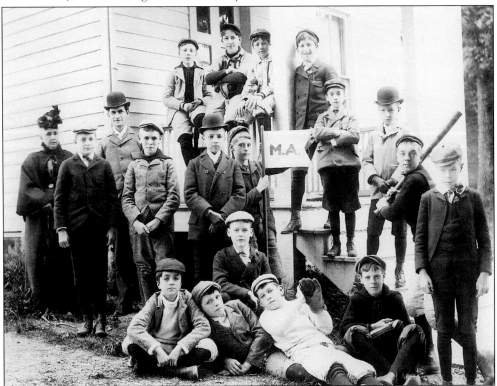

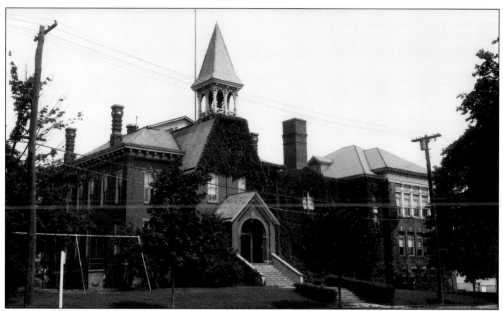

One of Madison's earliest "public" schools was Green Avenue School (above), which charged tuition when it opened. The central portion (with steeple) was built in 1872 at a cost of $17,350. Wings were added in 1897. The faculty and upper-grade students lined up (below) for an early 1890s photograph. All students were quite formally dressed. Only a few rebellious (or non-stylish) girls were hatless. Students desiring a high school education went to Morristown.

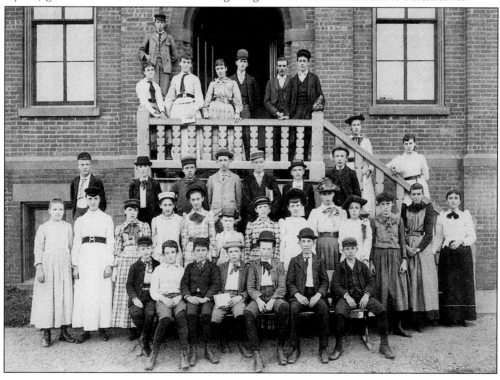

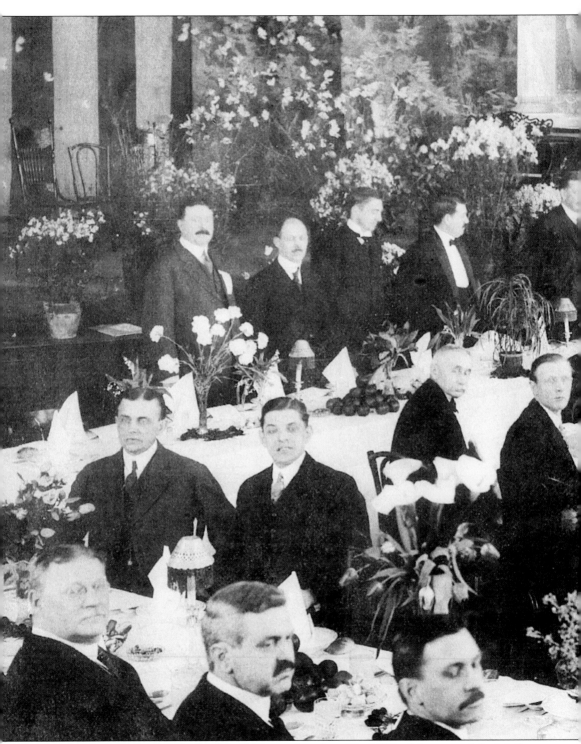

Madison's most distinguished and wealthiest males of pre-World War I days joined the Madison Board of Public Improvement. The group met annually in the spacious hall (above) in the James Building. They discussed past successes and planned future programs to make the town a

better place in which to live and work. The hall's much-used stage is visible in the photograph to the left rear.

The borough's reputation for superior dramatic productions was due in part to Madison High School's senior plays, directed for many years by Myrtle Hutchins. The presentation of *Expressing Willie* (above), staged in 1941, was a typical high school success. Kenneth Haynes (below), *Madison Eagle* publisher and drama enthusiast, directs a Green Door Players rehearsal for one of the group's notable productions on the second-floor stage of the James Building.

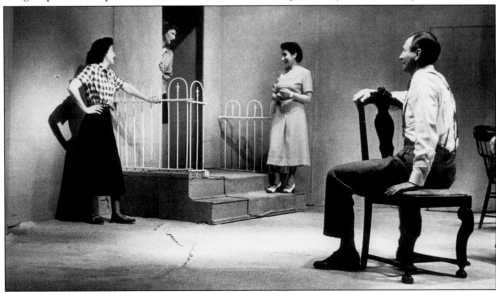

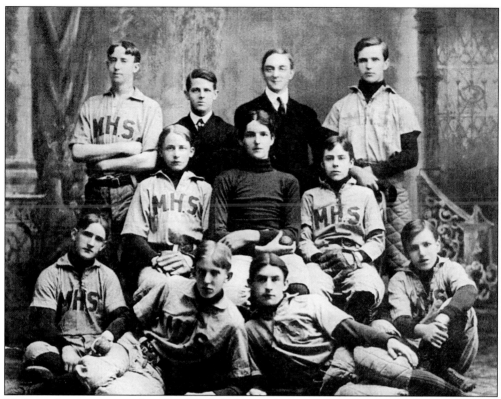

Madison fans were assured quality baseball for nearly a century, whether it was amateur, as in the Madison High School team of about 1900 (above), or semi-pro, as in the championship 1934 team (below). The early high school team featured only Madison players. The 1934 team, champion of the strong Lackawanna League, included men who had played on major-league teams, most notably Whitey Dressen (front row, fourth from left), who later managed the Brooklyn Dodgers.

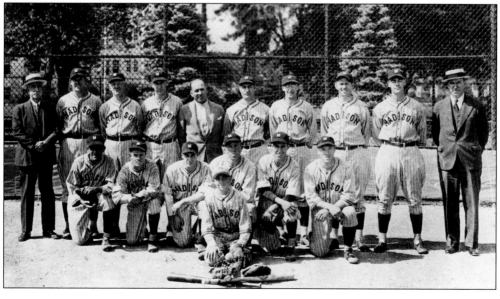

The Madison YMCA and Madison Public Library seemingly had a destiny to be neighbors on opposite sides of the same street. The YMCA, which had been opposite James Library on Main Street, moved in 1963 to a new facility built around this old railroad freight station on the north side of Keep Street. Six years later, construction of a new public library was underway—once more across the street (Keep Street) from the YMCA.

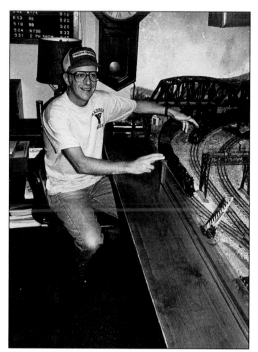

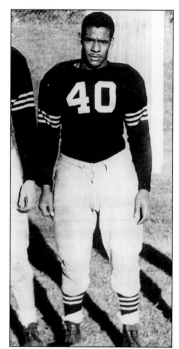

Three of Madison's unheralded twentieth-century benefactors were Bill Hopping (above left), George Burroughs (above right), and Rebecca Lassiter (below, third from left). Hopping donated more than $50,000 in receipts from his annual "Madison Central Railroad" shows at the Madison YMCA. Burroughs, football hero of 1940s Madison High School teams, became a major lifelong friend of local youth and was director of the Community House from 1968 until his death in December 1994. Mrs. Lassiter, an ordained minister and the town's foremost piano teacher, had many hundreds of students during her long lifetime.

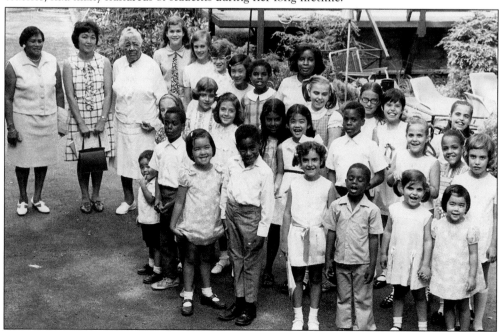

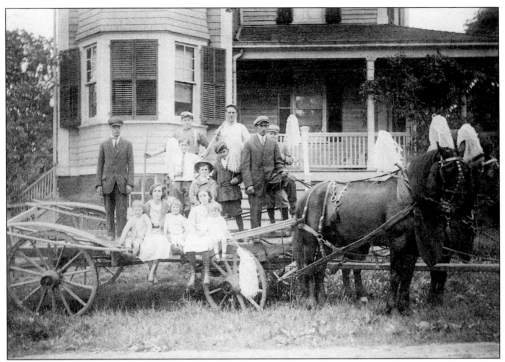

Just before World War I, when this Park Avenue group returned from a parade, decorated horses and a hay wagon seemed idyllic. Aletta Burnet Behre and several Park Avenue children are seated. Petie Farrell, later police chief, is also on the wagon. Twenty years later, a 1935 Ford had replaced the wagon, but when Mabel Diehl, Joe Pasalaqua, and Jane Hicks posed in front of the Lincoln Place movie theater, simplicity was still in order.

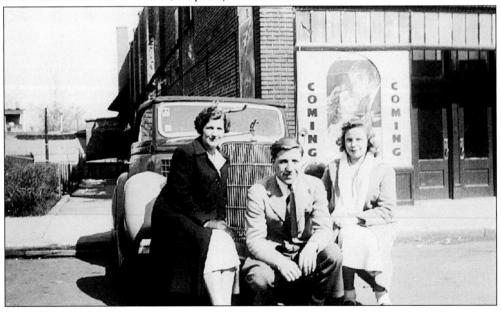

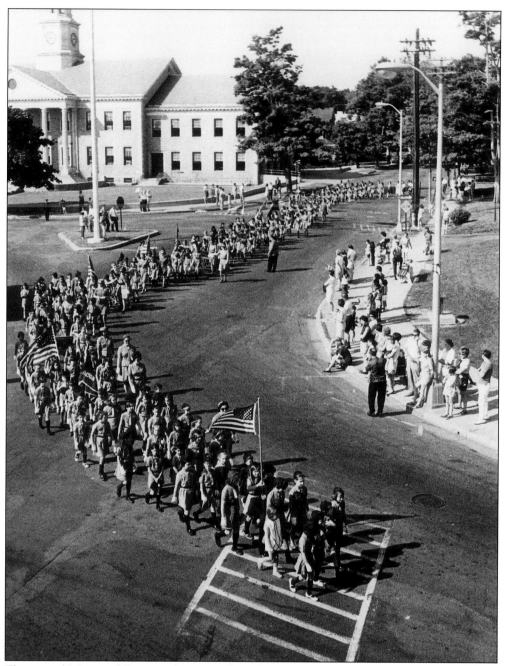

The annual Memorial Day parade in 1969 brought out large contingents of Brownies and Girl Scouts (as well as Boy Scouts and other groups) for the march down Green Avenue and past the Hartley Dodge Memorial Building before turning west into Kings Road.

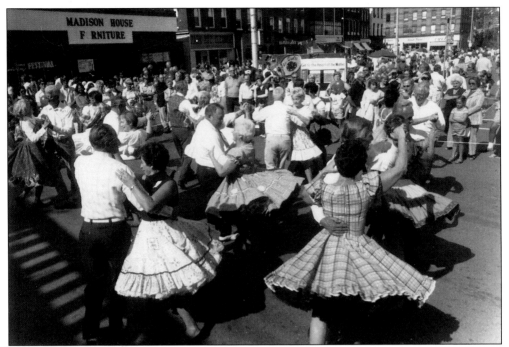

With a "do-si-do" and away we go, swirling square dancers brighten the annual Bottle Hill Day held in early autumn to observe the borough's traditions. Thomas Kean (below), former governor of New Jersey and now president of Drew University, shows a little girl how to use a camera at the opening of Drew's Child Development Center in 1990.

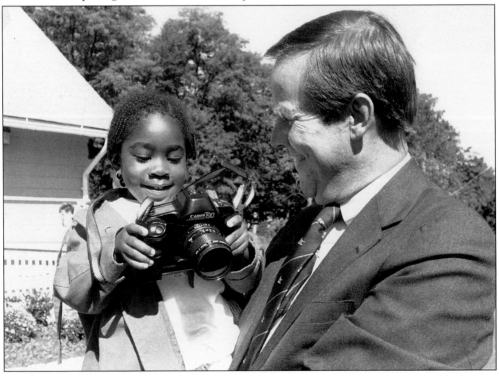

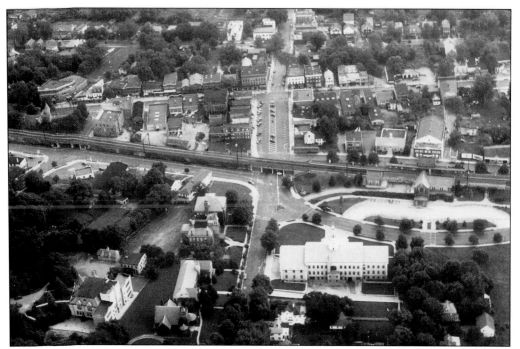

When Howard K. Morris took this aerial photograph (above) on a Sunday morning in August 1946, the town was much as it had been for 30 years—centered on the Hartley Dodge Memorial Building, with the railroad and Main Street cutting east and west. The next day (or any day) commuters would be back, racing to catch their trains. Most assuredly, at least one (below) would always be late.

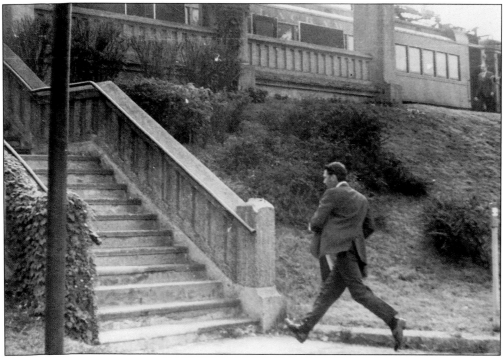

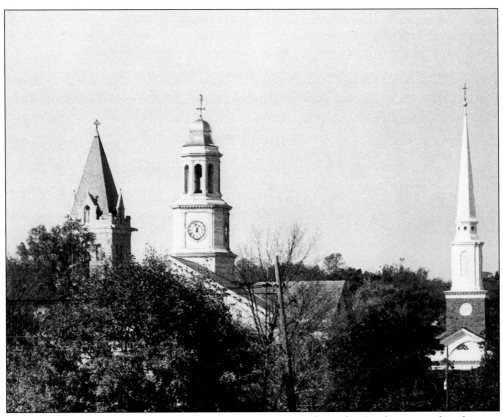

This symbolic scene has been unchanging since 1954, when the Presbyterian church spire became the third to pierce the sky above Madison near the railroad. To the left is the steeple of St. Vincent's Church. In the center is the bell tower of the Hartley Dodge Memorial Building.